SARAH LYNCH

77 Habits

OF **HIGHLY CREATIVE** INTERIOR DESIGNERS

ROCKPORT

First published in the United States of America by

Rockport Publishers, Inc.
33 Commercial Street
Gloucester, Massachusetts 01930-5089
Telephone: (978) 282-9590
Fax: (978) 283-2742
www.rockpub.com

Library of Congress Cataloging-in-Publication Data
Lynch, Sarah, [date]
 77 habits of highly creative interior designers : insider secrets from the
world's top design professionals / Sarah Lynch.
 p. cm.
 ISBN 1-56496-958-4 (hardcover)
 1. Interior decoration. I. Title: Seventy-seven habits of highly
creative interior designers. II. Title.
NK2115 .L97 2003
745.4—dc21 2002153954

ISBN 1-56496-958-4

10 9 8 7 6 5 4 3 2 1

Design: Mary Ann Smith Design
Layout and Production: Terry Patton Rhoads
Cover Image: Guillaume DeLaubier/Axel Verhoustraeten, Design
Copyeditor: Pamela Hunt
Proofreader: Stacey Ann Follin

Printed in China

SARAH LYNCH

77 Habits
OF HIGHLY CREATIVE INTERIOR DESIGNERS

INSIDER SECRETS

FROM THE WORLD'S

TOP DESIGN PROFESSIONALS

GLOUCESTER MASSACHUSETTS

ROCKPORT PUBLISHERS

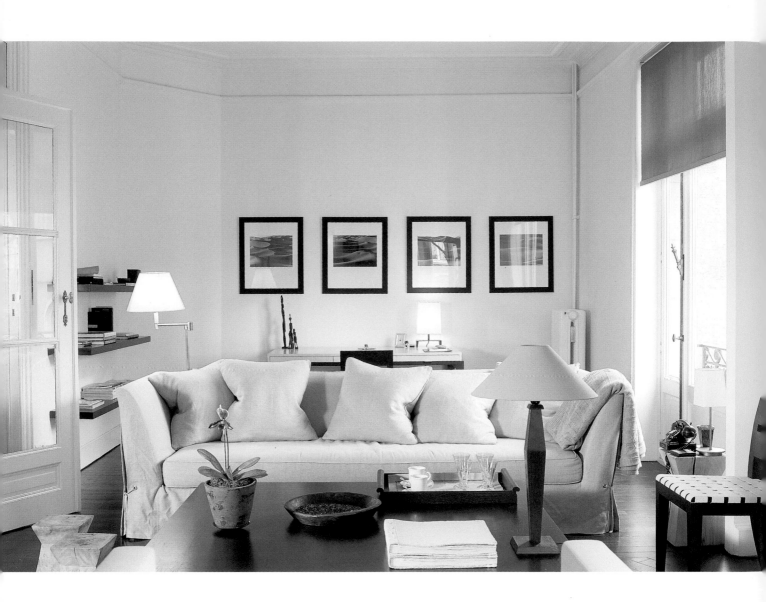

Contents

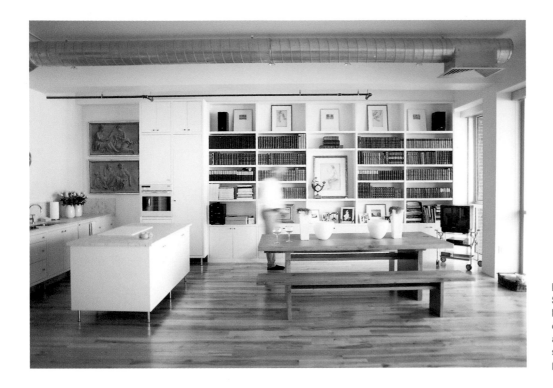

Boston designer Charles Spada injects contemporary loft living with a healthy dose of comfort by incorporating a wall of books and a picnic-style dining table in this open-plan kitchen/living room.

Introduction

As any child develops, she begins to mimic the sounds and movements made by those around her; eventually that child will learn to walk and talk by carefully imitating the motions of her elders. And then, in some type of Darwinian miracle, this very clever child will learn to observe, with an even closer intensity, the habits of the most successful beings around her—breaking down their methods in a step-by-step fashion. This is how the brightest, the most successful, and the most creative people have gotten to where they are today—by watching, listening, and practicing the approach of the professionals.

In the case of this book, the professionals are designers—specifically interior designers, decorators, and architects—and while some people may say that style cannot be learned, the habits of the stylish are surely something we can all learn from. For, like the child who watches her brother's curve ball, we need only to absorb, understand, and practice the steps in order to re-create that fine pitch. And, because not all of you are spending quality time with the world's most creative and cunning designers, we have done it for you: bringing together the methods, secrets, and advice from 12 of the world's foremost designers.

Chosen for their skills as designers as well as for their clarity in explaining those skills, the 12 designers who have participated hail from various countries and represent diverse styles.

Included in this book are decorators from New York, London, and Los Angeles; architects from Brussels, Milan, and New York; and designers from Miami, Boston, and Washington, D.C. Some are famous for the clean, modern lines in their projects, whereas others are known for their fascinating mix of vintage with new, or their ability to create a traditional, cozy atmosphere inside a contemporary loft space. In short, we have attempted to cover almost every style of interior design, touched on every realm of decorating, and hopefully answered most of your burning questions about how to make it work on your own.

Divided into three broad sections—Interior Design Basics, Habits for Each Room, and finally, The Finishing Touch—this book aims to break down the mystery of professional design services. Each section contains chapters that focus on a specific dilemma or design element that all designers face, from what to do with a "naked" window to how to develop a lighting plan. In those chapters are 77 habits, each a proven method for coping with decorating glitches or common concerns, such as Habit #36: Lighting a bathroom can be tricky—be sure to make it flattering, or Habit #6: Pick colors based on how you want the room to feel.

This book is meant to be used as a design tool. Interspersed with candid quotations from some of the finest designers of the 20th century, it contains more opinions than you need and all the advice you could ever ask for.

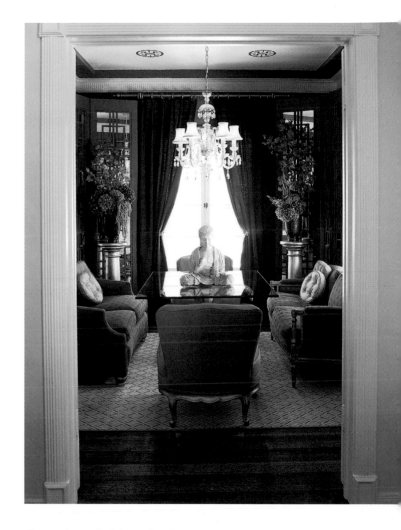

Symmetry and style go hand in hand for this Los Angeles living room designed by Kelly Wearstler. Arranging furnishings symmetrically not only is pleasing to the eye but also creates a restful space for living.

Profiles of Designers

John Chrestia

Chrestia has been practicing architecture and interior design since 1970. In 1982, he founded his own firm. Currently a partner in the prestigious New Orleans design firm Chrestia Staub Pierce, Chrestia specializes in the conversion of historic buildings as well as contemporary projects around the United States and abroad.

Robert Cole/Sophie Prévost

Based in Washington, D.C., the husband-and-wife team of ColePrévost has its roots in architecture: He's studied and taught at some of the world's most prestigious architecture schools, and she received her degree in 1990. Prévost also has an interior design degree. Their approach is an integrated study of each project that results in a well-conceived and modern aesthetic.

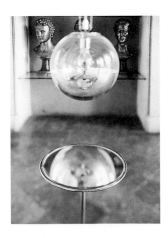

CLS Architetti Studio

CLS, a Milan-based firm founded by Massimiliano Locatelli, Annamaria Scevola, and Giovanna Cornelio, focuses on the restoration of classic monuments, large commercial projects, residential spaces, and exhibition designs around the world.

Celia Domenech

Brazilian-born Domenech began her career by tagging along with her interior designer mother. At age 17, she began to study architecture in Sao Paolo, and at age 23, she opened her own firm there. After many years of success in both commercial and residential design in Brazil, Domenech relocated to Miami in 1998, where she established Living Interior Design, Inc.

Heather Faulding

Born and raised in Johannesburg, South Africa, Faulding arrived in New York in 1980 to begin her noteworthy career in architecture and interior design. In 1988, she formed her own firm, Faulding Associates, which has since grown into F2, Inc., a full-service design company that specializes in all aspects of design, from architecture and landscaping to interiors and furnishings.

Tanya Hudson

Hudson is well on her way to design stardom, having completed her interior design degree in 1995 and becoming a partner in London's cutting-edge design team, Amok Ltd. She began her career designing hotels in southeast Asia and now focuses on using new materials and forms in both commercial and residential projects.

Thomas Jayne

With a master's degree in American architecture and decorative arts from the Winterthur Museum, Thomas Jayne opened his New York studio in 1990. Specializing in restoration work along with interior design, Jayne describes his work as "decoration and architectural history, both ancient and modern."

David Ling

New York architect David Ling worked under I.M. Pei and Richard Meier before opening his own firm in 1992. With a multicultural background based in China, Europe, and the United States, Ling's international firm has undertaken projects ranging from museum spaces to retail shops, offices, and residential buildings.

Laurence Llewelyn-Bowen

Best known for his vibrant television appearances on the BBC's *Changing Rooms* and *Fantasy Rooms*, this London-based interior designer opened his own design firm in 1989. Since appearing on television, his career has skyrocketed to include design commissions from flatware to furniture.

Charles Spada

In 1980, after a successful 12-year career as a fashion designer, Spada turned to interiors. His Boston-based firm Charles Spada Interiors is an award-winning fixture in American design and is known for its tranquil style and philosophy.

Axel Verhoustraeten

Brussels-based Verhoustraeten began his career in furniture design along-side Christian Liaigre and Philippe Hurel. With associations among Europe's gallery circuit, Verhoustraeten began showing his pieces at exhibitions such as Paris's Biennale des Antiquaires and Geneva's Salon de Mars, where he designed his exhibition stands. From there, his architectural career took form.

Kelly Wearstler

Los Angeles–based interior designer and principal of the firm KWID, Wearstler is known for her boutique approach to both residential and commercial projects. Wearstler's work combines vintage, contemporary, and historical elements for a truly eclectic and usually colorful result, be it a celebrity home or hot-spot hotel.

Section One

Interior Design Basics

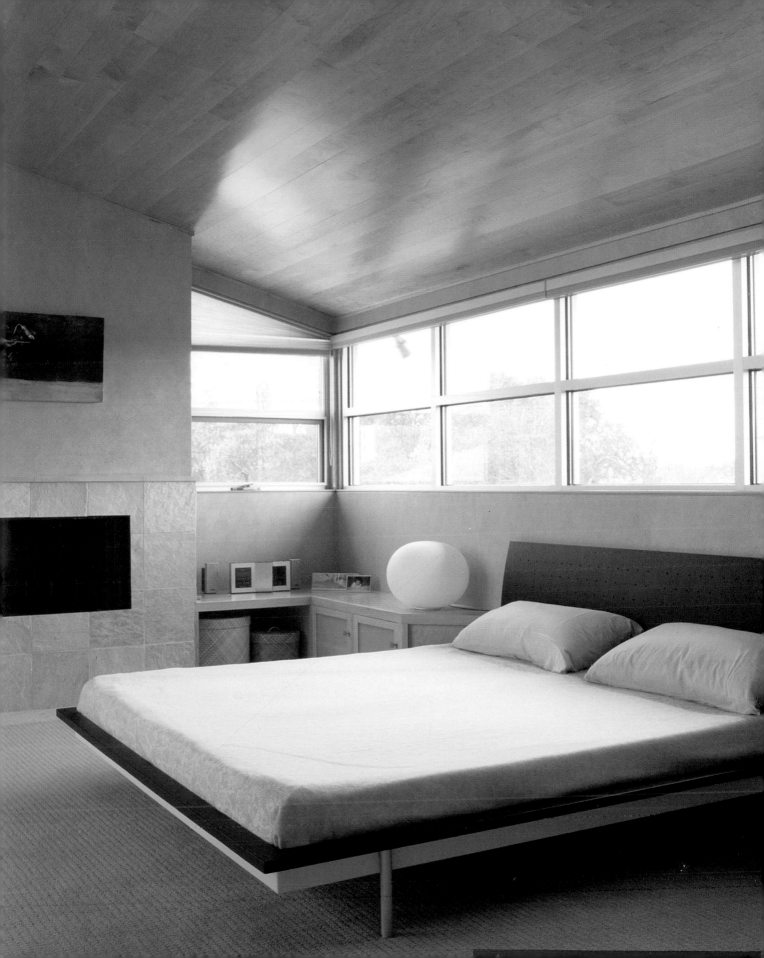

Chapter One: The Bones

Whether you call it the architecture, the structure, or the "bones" of a space, these are the elements you are stuck with—layout; location of doors, windows and walls; the height of the ceiling; and so on. And unless you want to reconfigure the bones, which is always a much larger and more costly undertaking than expected, you must learn to identify the positive and negative aspects of what you've got and take it from there.

01. Before doing anything with decoration, take a look at the structure of your home and identify its pros and cons.

Thomas Jayne: In new houses, after you have found a good plan, I look for beautiful windows, then fireplaces and doors. A beautiful window is placed to maximize view and light but also located to balance the architecture of a room. A window's framing shouldn't distract your eye or be weighted down with too much detail—just enough to please and work with the rest of the details in the room.

Laurence Llewelyn-Bowen: For me, the proportions of the space are paramount, and these proportions are most efficient when they are derived from the classical cannon of architectural relationships—which was derived from the harmony of thirds.

Robert Cole/Sophie Prévost: In general, we refer to the "bones" as being the elements that provide the overall organization of the house. Around these are organized the supporting cast of activities, spaces, and spatial separation, depending, of course, on what the needs and desires are. The richness of a house is in its program: It has both social uses and intimate, along with those that can, and often do, share a multiplicity of social uses, such as kitchens, dining spaces, entertainment areas, family rooms, and transitional spaces such as foyers.

Kelly Wearstler: I love a glamorous staircase at the entry, and fireplaces in a home are great architecturally. Make sure all doors are solid, and copper plumbing is a must.

Tanya Hudson: I have a particular pet hate of pokey hallways when you enter a home; I'd rather be welcomed by a large comfortable living space than by a narrow hallway with no natural light. This is one of the first walls that I'd look to knocking down if I'm working on a new layout for an old house.

John Chrestia: I look for the elements that make the house special, whether it's historical or period details or innovative architecture.

Celia Domenech: When you have good proportions, you have good bones. I would try to avoid narrow spaces and pointy angles. Instead, I would seek out spaces that unfold with a sense of ease—spaces with high ceilings and big windows featuring views and stressing a connection with nature.

David Ling: I try to imagine the space as a blank slate with only the structural "bones" remaining. I like to see large spans, large glass openings oriented toward the prime views, fireplaces, and structural walls at the perimeter rather than in the interior to make layouts more flowing and flexible.

Heather Faulding: Good bones, to me, are those that are simple and define the finished project very clearly.

Here, a wall of glass bricks provides the large opening oriented toward a prime view that David Ling considers good bones. The wall not only provides a view, but it is a spectacular light source for the dining area and helps bolster the overall mid-century modern feel of this house.

"The physician can bury his mistakes but the architect can only advise his clients to plant vines." —Frank Lloyd Wright, architect

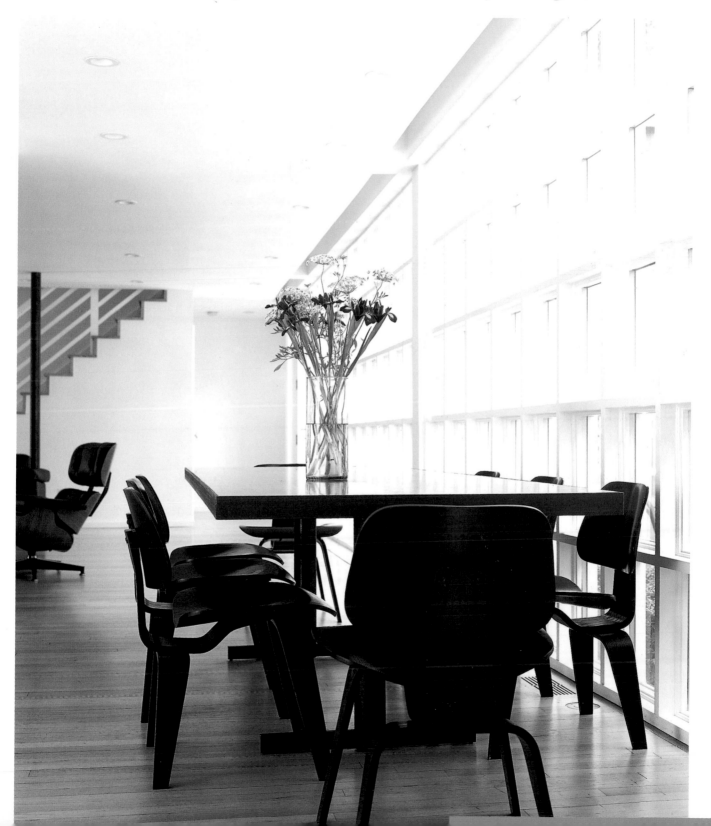

02. Determine organization, and measure how well the layout works.

Charles Spada: Avoid an "open floor plan," a "flexible floor plan," or "soaring ceilings," if suggested by your architect or interior designer. Unless this type of living suits your style, these terms usually mean that there are virtually no rooms, all volume, no walls, no charm or detail, equaling little or no privacy, generally for a lot of money.

John Chrestia: The first question that we ask a client is "how do you want to live?" We have to consider the way we live in a space before we determine the space planning—Do you want a living room and dining room combined for entertaining larger parties, or do you want smaller, more private spaces? Lifestyle elements should be the driving force in spatial organization.

Robert Cole/Sophie Prévost: Does it flow? Are the spaces well proportioned and do they flow well from one to the other? Or conversely, is there a good separation between those activities that you want to keep separated? Because we work predominantly in a modern idiom, our criteria—emphasizing such items as the flow of space, the relation of inside to out, and the eradication of corridors—would seem to be fundamentally different or even opposed to those of a more classical designer. However, this often is not the case. Well-proportioned spaces feel at ease or comfortable. The important thing to do is establish what *comfort* and *good flow* mean and use these consistently to create spatially coherent houses.

Tanya Hudson: A building with a steel structure is great, because it is really flexible—only structural columns and no structural walls dictating room sizes—so you can be really imaginative with the space planning. However, these structures usually exist only in large-scale buildings or very new houses. Understanding the structural layout of a building is important because it implies a logic to the spaces. That's not to say that the logic shouldn't be messed with, but it's a good starting point for knowing the balance of the structure. Drawing out how the building works on a plan is a great help when exploring the effects of any changes. From there, it is really easy to sketch out possible changes on overlays once you have the structural plans drawn out.

Perfectly proportioned and ideally situated around the inner courtyard and pool, this newly constructed house designed by ColePrévost was laid out to the specifications of its owners. Should you not be so lucky as this owner, there are ways to accommodate a less-than-logical layout.

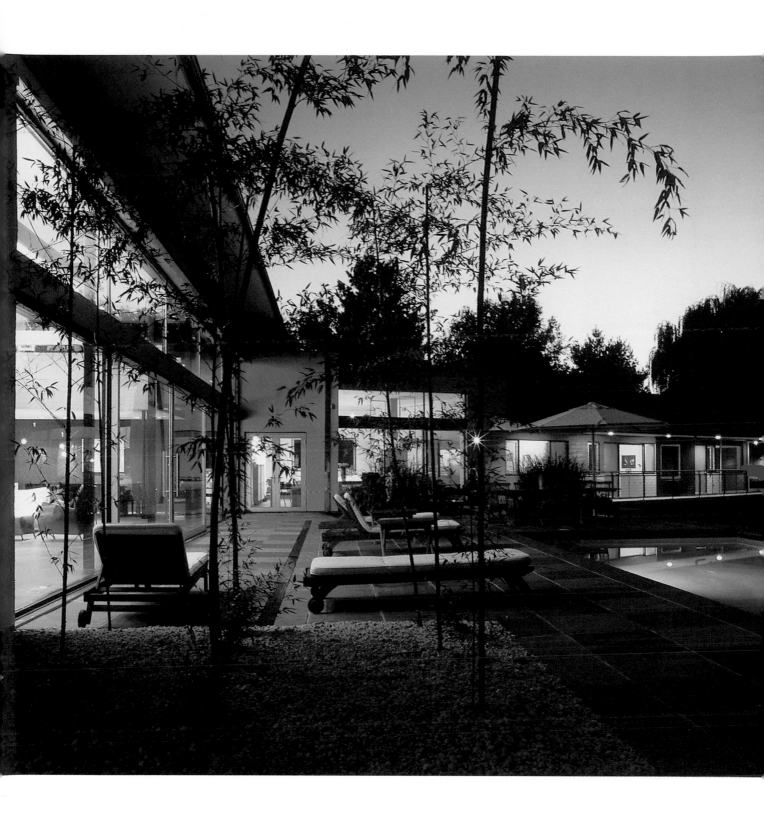

03. Get rid of the big flaws in any way you can!

John Chrestia: If there are elements that are just not working—additions made in the 1950s to an 1850s townhouse or ornamental elements that just feel wrong—remove or alter them right away.

Tanya Hudson: If there are major structural flaws, hire an engineer before touching anything. Any wall can be knocked down, in theory. It's just a matter of weighing the pros and cons, such as the cost and hassle over the gains in terms of size and feel of the space. Obviously, the lower down the building you go, the more problematic it becomes to remove walls as the load get greater.

Robert Cole/Sophie Prévost: There are no tricks for a bad layout. A bad layout is death; you need to go back to the drawing board to readdress the fundamentals. Sometimes, though, the solution can be as simple as removing a couple of walls, but the flow has to be thought through for the entire project. More often than not, poor layouts come from an organizational or planning approach that stresses a collection of uses, without taking into consideration how each space relates to the others, spatially, visually, or sequentially.

Heather Faulding: A badly planned layout can usually be easily resolved. There is very little that a fresh perspective and a new program cannot solve. Nine times out of ten, circulation is the biggest issue. Circulation, or traffic flow, when it takes up too much space, can be a problem. We usually deal with this by branching out the circulation into nearby, alternate rooms and hallways.

David Ling: There are three approaches to dealing with major structural flaws, depending on the budget, schedule/technical limitations, and the stomach lining of the client: first would be to redo, to correct the flaw; second would be to clad the flaws with cabinetry, dropped ceilings, or furred-out walls; and third would be to turn the flaw into an asset by repeating the flaw to form a pattern. Whatever I do, my goal is to integrate flaws within the overall design to appear intentional.

Laurence Llewelyn-Bowen: There are plenty of easy tricks for papering over the cracks and making inefficient bone structure look lovely in candlelight, but you should really ask yourself if you can live with that kind of compromise. My advice is to not even attempt to engage in any architectural work, but to catch the eye using colored, patterned, or textured accessories and to save up and alter the space properly at a later date.

Thomas Jayne: Paint, like good face makeup, can hide many sins—sometimes lighting can do the same thing. But a bad plan, or a major flaw, is never easily hidden.

When creating a dining space in his loft, designer Thomas Jayne used floating walls and color blocks to carve out the "room," making the space more intimate and giving the impression of a cozy dining nook.

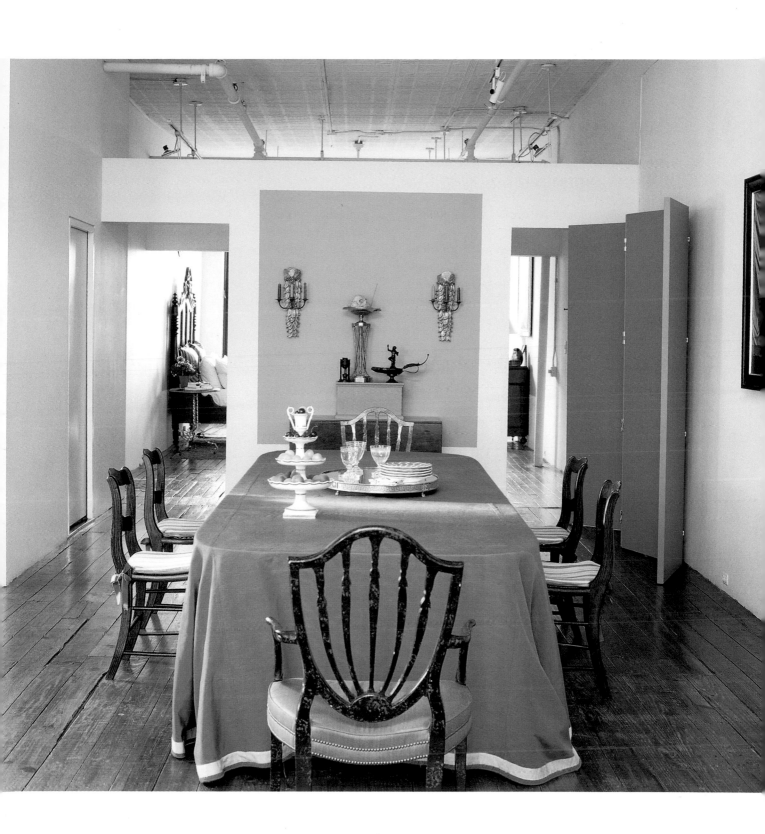

04. Disguise or hide the flaws you can't get rid of.

Charles Spada: Minor imperfections, such as walls in poor condition, are best camouflaged by a coat of dark paint and or fabric-upholstery. These two options hide a multitude of sins. Adding built-ins can hide a multitude of structural sins while providing architectural interest and bonus storage and display possibilities.

Axel Verhoustraeten: There are a number of tricks and ruses for covering up problems, such as changing the material or shade or creating fake perspectives. I would stress, however, that one should never attempt to cover up a defect before trying to fix it, because "faking it" only highlights it further.

Tanya Hudson: When you have structural elements in a place that you don't really want to see them, like a column in the middle of a room, an easy way to disguise them is by constructing a partition wall of sorts next to or around the column, be it a wardrobe, storage, or glass feature, thereby giving that column a purpose.

Heather Faulding: For recurring flaws throughout a building, the question is "to dress or undress?" Sometimes undressing a covered flaw is surprising in how much it makes it disappear.

Laurence Llewelyn-Bowen: You can raise low ceilings by cheating the arrangement of architectural elements, such as skirtings, dados, and cornicing, reducing their height to increase the perceived distance between the floor and ceiling. And it may be a bit like *Alice in Wonderland,* but short doors really do trick the eye into perceiving the room as taller.

Celia Domenech: For narrow spaces, if construction remodeling is not allowed, I would install a mirror and consider a lighter color palette.

Robert Cole/Sophie Prévost: Some quick fixes—Windows too low in a room? Set the window treatments above the windows, at a height that will work with the proportion of the room. A roman shade, for example, will cover the wall space above the window gracefully. Room too tall? Set a horizontal datum, or reference line, around the room. When you set this line at or above a person's height, it creates a "room within a room" and therefore helps make the space more intimate. It can be done by using different materials, such as wainscoting, or different colors, or textures.

Kelly Wearstler: Add paneling or millwork, such as casing or crown molding. Wallpaper can help with the bad details as well. As for badly planned layouts, a great furniture plan with the help of screens and floating seating arrangements is helpful.

John Chrestia: Paint out any elements that don't work, to lessen their impact. If you have natural millwork or exposed brick, stone, or any texture that just doesn't work with the space, use paint to disguise or diminish the impact.

CLS Architetti Studio: Architecture has to be honest. Therefore, it's much better to declare the flaws instead of hiding them. For example, in a historical villa we are now refurbishing, we have joined two fresco-ceilinged rooms, and the space in between has been transformed into a big lighting fixture.

In this long alley of space, the major source of natural light comes from windows along one wall. In order to split up the space for privacy without sacrificing the light from the window wall, Belgian designer Axel Verhoustraeten designed this hallway/storage unit to divide the space lengthwise. For more privacy, a series of graphic vases are lined up on top of the wall and serve double duty by drawing the eye forward and making the long hallway seem logical and natural.

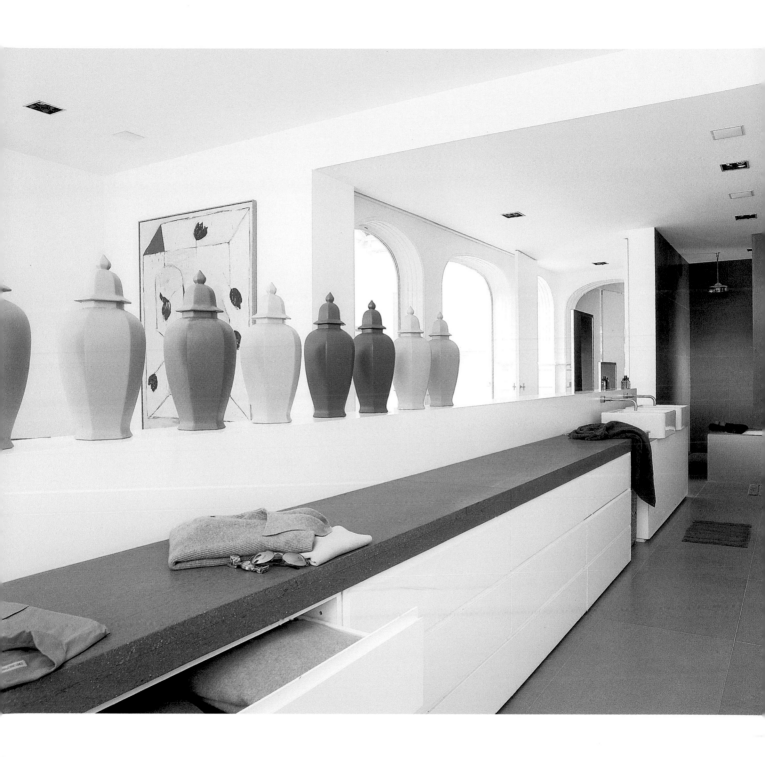

05. Play up your best feature—highlight those beautiful bones!

Laurence Llewelyn-Bowen: Color and texture are eternal allies in fashion for drawing attention to good features. There is an increasing trend in using "fashion solutions" for the good of interior design. A small waist is celebrated by a glossy black patent belt, an impressive cleavage by a sweetheart neckline, and long legs by skinny cigarette pants. Dress your room like you dress your body, emphasizing and minimizing in turn to promote the best features—strong color comes forward to meet the eye, whereas pale neutrals recede—so a fine mantel framed by a glossy red chimney breast in an all-white room underlines the most important feature of the space.

Celia Domenech: Frame your home's finest elements, and make them focal points. In other words, don't compromise the clarity of the strength of a design.

CLS Architetti Studio: In our experience, Europeans are more fond of refurbishing an old building instead of building a new one. Therefore, our approach is to highlight the existing structure. Light is the best way to highlight the material of architecture—space, structure, and materials.

Thomas Jayne: Mirrors have always been the best way to highlight attractive aspects. You can place them on any feature—walls, ceilings, door panels, or skylights.

Tanya Hudson: Exposed structural elements can be quite stunning in the right context: steel I beams or old cast-iron columns in warehouses. Contrasting colors or materials will separate the structural element from the rest of the room, and light colors in particular will create dramatic shadows to really emphasize the structural form. Also, rather than filling in between columns with walls, it's nice to use glass, be it clear, opaque, textured, or colored. It creates a more interesting and subtler division between two spaces and can help bring borrowed light into a room. This also highlights the structure as an interesting marker in the space.

Charles Spada: Don't block wonderful wood paneling, architectural detail, or old beams, or smooth out unexpected wall jogs, niches, or interesting imperfections. Don't cover up beautiful floors, whether they are old or new, wood, stone, or even inlaid linoleum. Don't cover up beautiful windows or views with unnecessary window treatments. Keep window treatments minimal and easily relegated out of the way.

David Ling: Good bones are best enhanced by giving them air to breathe and leaving open vistas in which those structural elements are exposed.

Axel Verhoustraeten: Simplifying or returning something to its original state is the best way to highlight the good features of a building. Often, things will have accumulated unacceptably over time, and this is detrimental to the quality of the building. Decoration is a major disease in this respect.

Kelly Wearstler: Selecting contrasting paint colors on walls and millwork, as well as various finishes, can quickly play up your home's best features.

John Chrestia: Sometimes it's the beautiful bits and pieces that make a room special. There are ways of highlighting these aspects without overdoing it. For instance, to play up a wall of windows, leave them bare and place furniture in front of them to contribute to the transparency.

In this new building, the architectural details—archway, staircase, support beams—are so graphic that Tanya Hudson simplified the decoration in order to call attention to the details. The creamy walls were left almost bare, and the dining table blends with the wood of the floors and storage system. The marching bolt of color, with chartreuse chairs, also calls out the linear quality of the space.

Chapter Two: Color & Materials

It may be categorized here as elementary, but the science of mixing and matching colors and patterns is hardly an easy one to master. It is clear from the designers' commentary below that the colors and fabrics for an interior design project are chosen with thought, care, and scrutiny. As they should—not only do color and light determine the mood and atmosphere of a room, but an interesting mix of patterns, textures, and color can also make or break what could otherwise be simply good design.

06. Pick colors based on how you want the room to feel.

Thomas Jayne: A traditionally detailed room might feel more modern if it is simply painted in one color. On the other hand, a modern room could benefit from the presence of several colors playing against one another (as I did in my own loft). In other words, never say never—color always depends on the circumstances.

Tanya Hudson: Start with the mood you're trying to create, and consider the lighting at the same time—colors vary with different types and amounts of light. I tend to use different textures and tones within a particular color group: leather, suede, plaster, and different types and cuts of timber, all in varying shades of brown. This gives a sense of continuity and restfulness to a space. Too many colors appear as individual items, breaking up the room rather than creating one continuous space. It's also nice sometimes just to have a single contrasting color to liven up the mood a bit.

Robert Cole/Sophie Prévost: Decide what type of atmosphere you wish to create. Colors help influence moods. Think of colors you like, and don't be shy about using bold colors, but be careful not to overdo it. For example, the color fuchsia, which would be too overwhelming used on four walls of a room, could be stunning on one wall as a backdrop.

Laurence Llewelyn-Bowen: Use color to create an environment appropriate to the use of the space. Warm, rich hues are perfect for evening entertainment; bright, atmospheric pastels for vigorous breakfasts, and closely harmonized neutrals are ideal for creating peace and tranquility.

Celia Domenech: For a calming, minimalist feel, I use neutral colors for large pieces of furniture. Then I add one or several other colors to accessories or small upholstered elements. This way, they are easier to change if you get tired of them.

Heather Faulding: Color should be determined by the use of the space and its setting. Simple, light colors can make for peaceful spaces, but don't be afraid of brighter colors. Most people seem to go back to the safety of white or beige. There's no question that these are fresh, clean colors—we use them often, particularly when there is vivid artwork and electric colors in furniture and finishes—but we prefer a brighter, more European color palette.

Kelly Wearstler: Consider how you would like to feel in the particular space and how much natural light there is. And always buy quarts of paints and see if you like them on the wall before you commit to a gallon.

A saturated shade on the walls and upholstery combined with mirrored accents and a zebra rug allows color to be the guiding design element. As a whole, the space, designed by Kelly Wearstler, feels energized, welcoming, and stylish.

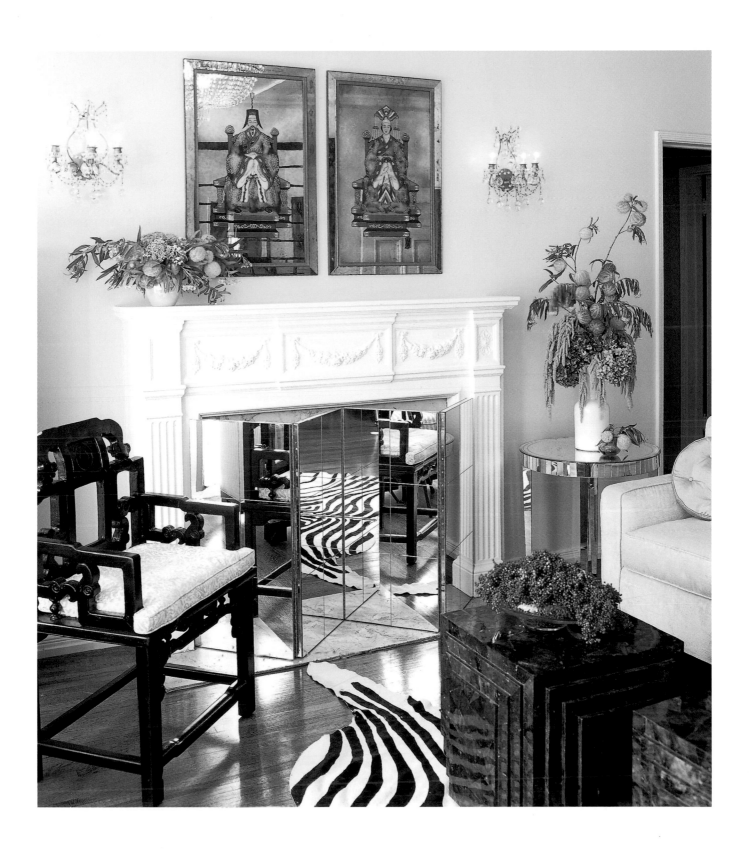

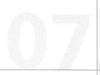

Choose natural color combinations or pick contrasting accent colors.

Laurence Llewelyn-Bowen: I always think of color as flavor—a rich strawberry red tastes and looks great next to neutral creamy cream. But how much more sexy is that combination if you throw in a hint of bitter chocolate?

CLS Architetti Studio: We did a flat in Italy where we worked from the color palette of a cyclamen, using the different shades of green with different textures on the fabric, walls, doors, and so on, as well as the different tones of purple, from when the flower is blooming through when it fades.

Thomas Jayne: Try to have all the colors in a house be either warm or cool in tone. Personally, I like colors infused with yellow or sympathetic to it, because it creates an overall sunny feeling.

Robert Cole/Sophie Prévost: Contrasts are important. Even in a neutral color scheme, punches of color are necessary to add strength to the scheme. These can be introduced in the color and material palette of the architecture (for example, dark wooden floors or a bold accent color on a wall) or within the furnishings and accessories. When using strong contrasts, it is important to balance their use within the room. However, balance does not equal symmetry. A deep red accent wall in a white room will work better if some items in the room are of a similar intensity, though not necessarily in the same color, such as a series of dark wooden frames or a group of objects in bright colors.

Axel Verhoustraeten: Color should simply magnify natural light. Combinations and their significance should be left to art.

Charles Spada: I generally use a single paint and fabric color throughout a home, with the exception of a room or two, which are treated with complementary—directly contrasting—colors of the same hue and value as the predominant color.

CLS Architetti Studio: Start from nature. Observe it. It is the perfect mix of colors and textures. For example, match the blue of the sky with the matte green of the grass and the shiny yellow of the sunflowers.

Just as CLS Architetti Studio suggests, the combination of a matte-finished green with a pulsating violet instantly reminds us of a flower set against a backdrop of grass. It immediately feels natural and energizing—a perfect combination, especially when set against a sea of marble and natural wood floors and built-ins.

"One of my favorite colors is no color at all."
—Billy Baldwin, interior designer

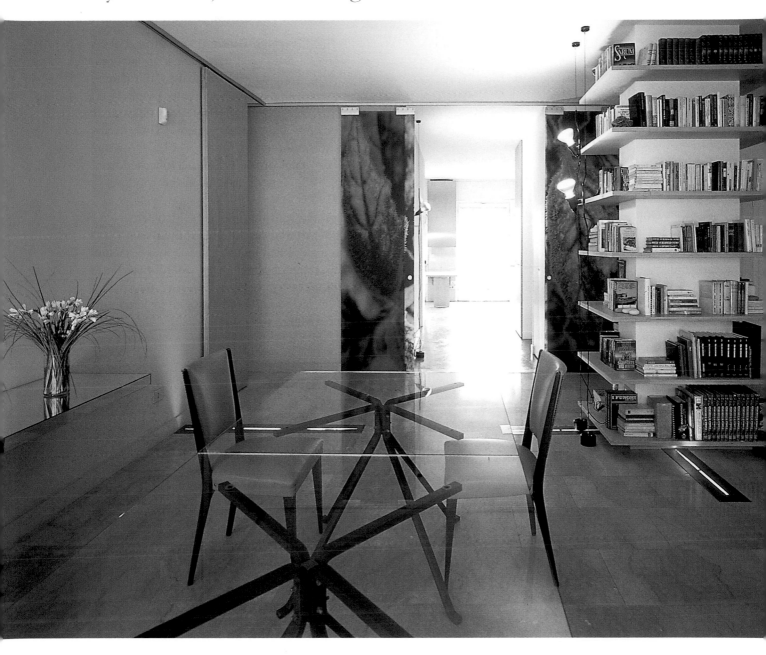

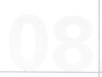

Consider how your colors will look with your furnishings, materials, and lighting in the space.

Robert Cole/Sophie Prévost: Start with what you have and intend to use—furniture, special collections, artwork—and draw inspiration from them. Also, some pieces, such as a large, colorful painting, may have to be a starting point. Clearly, the color scheme in that room has to work with the painting.

Tanya Hudson: I tend to use subtler colors in larger spaces and really bold colors in small spaces. It's fun to go mad in a little room, but it can be a bit overpowering in a large, open space.

David Ling: I imagine the space and my client's furniture and collection with the elements that are staying to form the basis of the composition. I choose the most dominant piece and allow that to guide me.

Charles Spada: Color is subjective and should be chosen with great care. It is probably the most important element when planning rooms to live in comfortably. Colors should flow easily from space to space without being jarring to the eye.

Celia Domenech: First I analyze the structural elements of the space. I study the size, shape, and quality of light and its usage. In short, I analyze the whole environment. Then, I pick a main color, and I play with it.

Laurence Llewelyn-Bowen: Don't forget about *you* in the room. Flame-red hair against an aubergine suede wall is a little slice of heaven, but flame-red hair against flame-red wallpaper creates overkill and ultimate invisibility. It's extremely rare to have literally carte blanche with a color scheme. There is always an imposed starting point, whether it be an existing floor finish, the color of the sideboard inherited from Granny, or a view of trees from the window.

Heather Faulding: Sometimes, a color choice comes from the material on the floors, the tiles on walls, or even the wood cabinetry. These tones sometimes dictate the starting point. But be careful that you don't try to incorporate too many tones. I would say that four colors in one room is the absolute maximum, though, I would even go for three.

In the case of this living room, the color choice was dictated by the existing Arts and Crafts–style windows and doors. As a way of referring to this woodwork as well as to the view outside the leaded windows, Laurence Llewelyn-Bowen began with an evergreen shade on the walls and upholstery. Using several textures, all in the same tone, this specific shade of green fits with the preexisting elements.

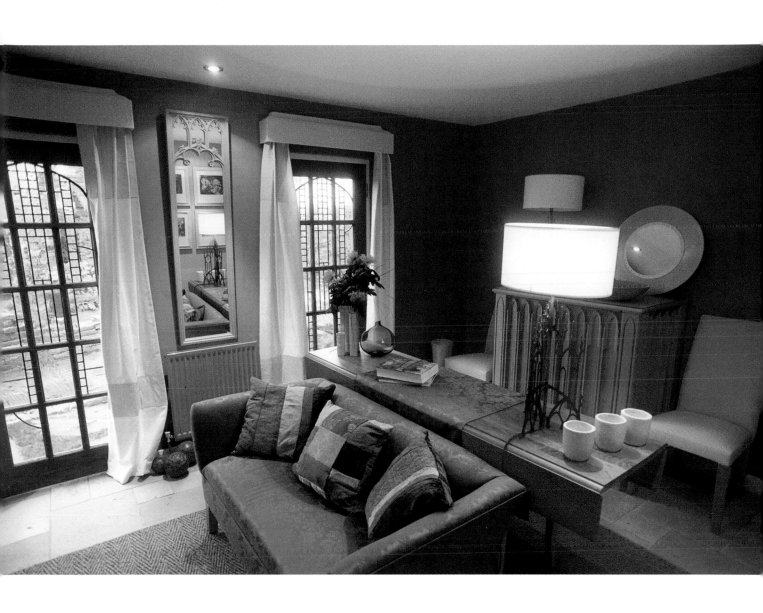

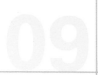

Consider fabrics and materials before or at the same time as the color palette.

Robert Cole/Sophie Prévost: Fabrics and materials need to be selected at the same time as the color palette, as part of a master plan. Sometimes, the whole color scheme of a room may be based on a fabric. Of course, the types of materials and fabrics and the color scheme must go hand in hand with the mood you are trying to achieve. Even if implemented in phases, it is essential that all decisions be part of a coherent whole.

Thomas Jayne: I try to select the textiles first, especially the carpets. It is easier to find a great color than a great rug. Select wall colors that speak to the dominant shades of the fabrics and carpets, not necessarily matching them. You can begin with a color and then shop for fabrics, but do not paint the walls until the textiles are in hand.

Tanya Hudson: Samples of all materials that are going into the room should be brought together, ideally with some idea of the proportion that they will be used in, as well as alternative options and lighter or darker versions of each sample.

Heather Faulding: We often go to fabrics first when choosing colors. They can provide inspiration for the rest of the scheme. Our fabric drawers are grouped by color and pattern, so we frequently start with one color that we have in mind and let the fabrics guide us toward other shades and colors.

Celia Domenech: I consider fabrics and materials simultaneously with a color palette. Only then I can achieve the sense of harmony and balance that I strive for. Part of this process requires checking the selections against a budget and making substitutions and adjustment along the decision-making process.

Charles Spada: Color should come first in planning a design scheme, then carpeting, then fabrics, which probably outnumber carpets 1,000 to 1.

Kelly Wearstler: Selecting fabrics, materials, and colors should all come together. Gather small samples of the elements you would like to combine—the better to play with. Consider how wood textures work with fabric textures and paint finishes. There should be differences in all of these, but they should work harmoniously. Do not be too calculating. Have fun and make sure there is a good mix of pattern, especially texture.

John Chrestia: I usually choose a color philosophy by starting with fabrics and textiles because fabrics are expensive, whereas paint is not and can be scrapped if necessary.

A room designed in fabrics and colors that are just off from one another—say, the sofa upholstery in peachy orange and the walls in tangerine—can be a disaster. Here, designer Tanya Hudson found an exact match to the bedding for the wall color. The result is a cohesive scheme that feels well thought out and finished—even when the bed is unmade.

Mix unexpected and contrasting textures in fabrics and materials.

CLS Architetti Studio: When refurbishing, we usually preserve some materials that are typical of the period and join those with contemporary materials, sometimes treated with the same technique as the old ones. For example, original Italian terrazzo pieces from a location are repurposed with poured concrete for flooring throughout the interior.

Charles Spada: Textures should vary from soft, silky, and smooth fabrics—such as taffeta and heavy silks—to rough textures, natural linens, and transparent gauzes. The weight of the material should also vary. Try combining flannels with loose and tightly woven wools and cottons with sheens and matte finishes. Combine the deluxe with the common—it's unexpected and interesting.

Laurence Llewelyn-Bowen: Textures are at their best when they spring from their opposite. A shiny lacquered wall on which is hung a rough, antique stone Thai Buddha head provides a tactile symphony where both textures are shown at their best. Be aware, however, that rough, matte surfaces absorb light, whereas slick, shiny ones bounce it back.

Tanya Hudson: You create far richer spaces by introducing colors in different materials. For example, it's much more interesting to put lime green leather against a beige wall than it is to just paint an element lime green.

Thomas Jayne: Although unexpected textures and materials can look fabulous, formality, suitability, and cost always play into the selection of materials, no matter who the client is. You must also consider the "hand" of the fabric—no one wants an inappropriate choice, say, $1,000-a-yard brocade in the pool cabana.

Axel Verhoustraeten: The choice of material is, of course, above all a matter of common sense. But let's not exaggerate—materials sometimes do warrant their place, and a living space shouldn't necessarily have to earn its keep or bow to household chores.

John Chrestia: Choose enough materials and textures to make a room interesting and to provide a variety of contrasts. Pair shiny with dull fabrics and nubby with sleek.

In this living room, designer John Chrestia practices what he preaches. Having married several textures and tones of fabric and materials in this room, the result is varied and interesting but not overwhelming. Muted contemporary fabrics combine with iridescent accents, and satiny textures play off traditional rugs and silk upholstery.

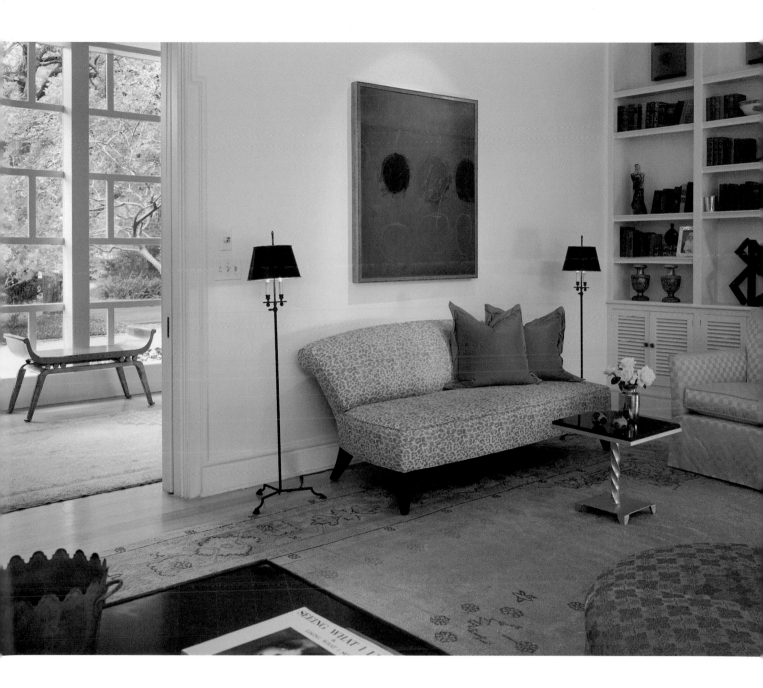

Chapter Three: Space Planning & Furniture Arrangement

Sometimes it seems that only professionals worry about space and layout. Space planning is what sets experienced interior designers apart from the rest of us. Undoubtedly it's a mix of talents and habits that set them apart, but laying out and creating space is definitely one of the trickier aspects. Whereas many homeowners are worrying about which wall to set the sofa against, the pros are contemplating scale, proportion, and breathing space between furnishings and architecture. It may seem abstract and complicated, but a good layout may just give your rooms the star quality you are searching for.

11. Stretch out the space you have.

Kelly Wearstler: In order to make a room feel larger, create a monochromatic space using one color of paint, wall covering, and carpets in various textures. A mirror is an instant space enhancer. Cover an entire wall with mirrors. Or just use plenty of reflective surfaces—glass or Lucite tables open up space.

Celia Domenech: To create the feeling of a larger space, I use light colors, a mirror, and, if possible, enlarged windows. If the architecture allows, I would add outdoor lighting for nighttime; it makes your attention go beyond the room's limits.

Heather Faulding: Use light as much as you can. If you can use the ceiling as reflector, that's your bright sky. Make more and bigger windows, and don't ruffle the light out of them.

David Ling: I like to establish a spatial flow that leads from one space to another in a discovery procession. If that doesn't work, buy a larger place. Just kidding!

Tanya Hudson: Continuous floor treatments help spaces look bigger, and long, thin proportions—such as a wooden floor continuing along the length of a room, into the hall, and into the next room—also extend the space. The same is true for wall treatments.

Robert Cole/Sophie Prévost: In general, lighter colors make a space feel larger. Also, having the same floor treatment between spaces provides a better flow and helps erase the clear definition of where one space stops and the other starts.

Charles Spada: Keep it minimal in smaller spaces, with each piece complementing the rest of the furnishings and architecture. Furnish to scale in rooms both large and small. Edit, edit, edit. For every five things you put in a room, delete four. Let a few pieces shine rather than allowing too many becoming a blur.

Thomas Jayne: What's the best way to make your space look bigger? Mirrors and medium colors that throw the corners into shadow.

By raising the bed and side tables off the floor, designer Thomas Jayne added the illusion of more space to this smallish bedroom. Additionally, the use of a painted color square as a frame for the furnishings allows the corners of the room to stretch out in their whiteness. And don't forget the mirror—always helpful for creating the illusion of space.

"It's not about buying furniture and filling space. It's creating space." —Suzie Frankfurt, interior designer

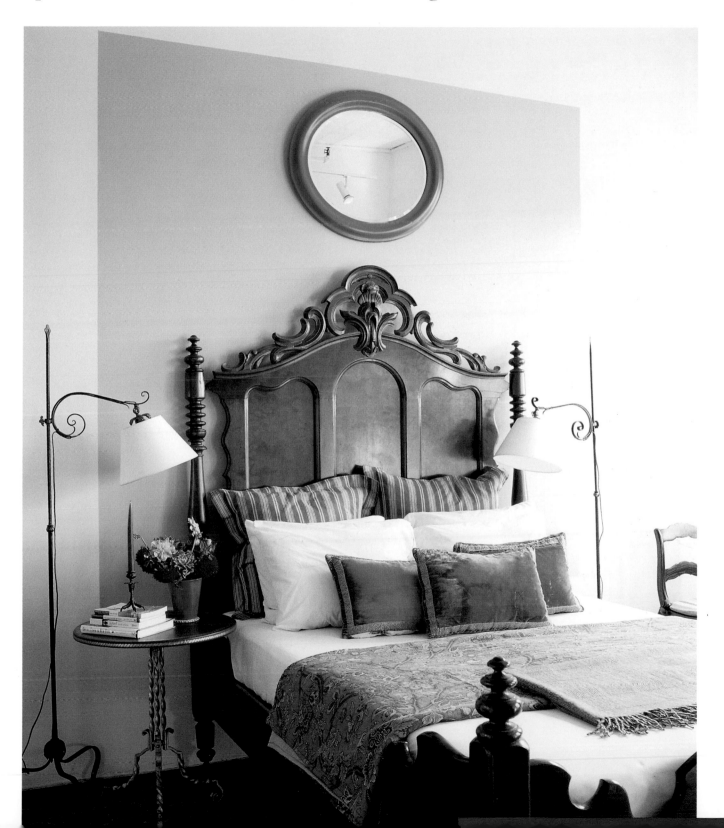

12. Make huge rooms feel homey.

CLS Architetti Studio: Architecturally, you can create a room within a room—a sort of anti-loft theory—where the inner volumes allow you to perceive the amplitude of the space. By carving out little niches, you can find the right proportions with the human body.

Robert Cole/Sophie Prévost: Warm, darker colors make a room more cozy—don't forget the option of painting the ceilings. The scale needs to be intimate and small. A small, dark room with rich, warm hues is wonderfully cozy, but lighting is the key there.

Thomas Jayne: To create a cozy space, try incorporating things that are more textured, like velvet, burlap, or fur—fake, of course!

Laurence Llewelyn-Bowen: Concentrate and emphasize your living activity in the center of the room. Defining a room's boundaries with furniture automatically draws attention to the inadequate proportions of the space. Take a leaf from the classic country decorating book and create a room within the room by arranging your furniture around a centrally placed, brightly colored rug.

Heather Faulding: Usually, warmer colors cozy up a space. It doesn't have to be dark beige—even a strong orange works. Also, go for more dramatic window coverings.

Tanya Hudson: Cozy rooms are created by soft materials. For example, fabric-padded walls make a room sound, look, and feel cozy.

John Chrestia: To make a large room feel cozy, you have to create a comfortable furniture and space plan. Consider designing a nook-like seating area or using warm colors. Oranges, pinks, and reds are more cozy feeling than cooler colors. And you must consider that a pool of light from a table or standing lamp is much more comforting than a flood of light from overhead.

Warm colors, soft textures, and well-designed lighting all come together in this cozy sitting room to create a nurturing space from an otherwise bright white box. Laurence Llewelyn-Bowen also used his method of drawing most of the furnishings and activity into the center of this room to carve out a comfortable conversation spot.

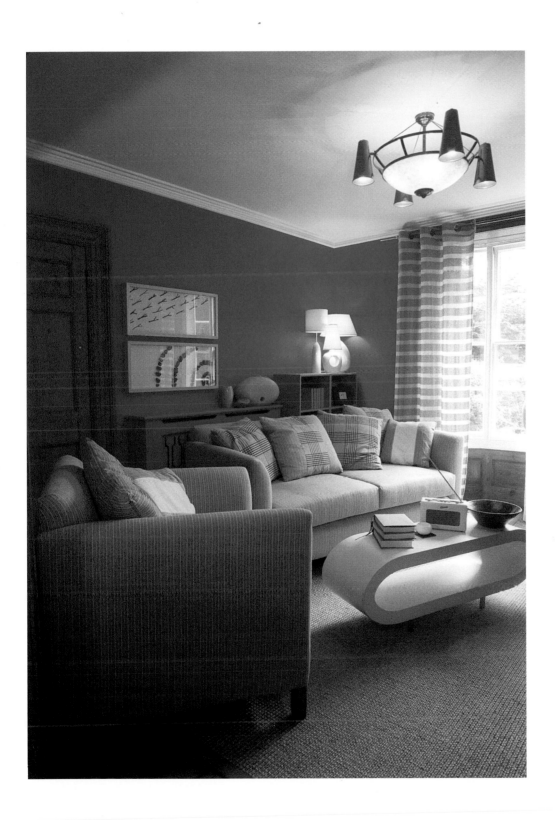

13. Furniture arrangement should start from logic.

Robert Cole/Sophie Prévost: The entry or arrival into a room is very important, because this is the moment when you see, appreciate, or even understand the overall atmosphere of the room. When arranging the furniture, think about the flow and the experience as you enter the room as much as the way the space will be used. For example, upon entering a living room, you don't want to be faced with the back of a couch and have to awkwardly turn around it and several side tables before sitting. The seating arrangement should be welcoming and graciously accessible. Often, we try to create a dynamic symmetry, where one element or item is balanced by another in a different location. You can do this using a variety of items, such as scale, objects, textures, colors, and lighting.

Heather Faulding: You don't want to have your back to people entering the room. Feng shui teaches this, along with many other useful practices, so it's a methodology that is worth looking into before proceeding with the design.

Thomas Jayne: Think about the conversations that will take place and the most comfortable arrangement for the seating. Always have a place to put a drink. No one jams all the furniture in one corner unless it's an artist's studio.

Laurence Llewelyn-Bowen: Never have eyes bigger than your stomach in furniture terms. It is essential to draw up a plan to ensure that the piece fits, works, points in the right direction for watching TV, allows for conversation, and makes the most of available light. I personally loathe furniture wedged up against walls. Even if you can draw a console table 4 to 5 inches (10 cm to 13 cm) away from the wall, it creates a feeling of space and air.

Celia Domenech: My main preoccupation when choosing and arranging furnishings is the circulation of traffic and my client's comfort. It's also nice to have enough space between pieces that each one can be appreciated on its own.

Axel Verhoustraeten: Lighting and traffic flow are two good starting points for arranging furniture, and nowadays, user-friendliness is also very important.

The arrangement of furniture in this living room designed by Axel Verhoustraeten was carefully planned to create a conversation area in the center, while using the perimeter for storage and decoration. Set perpendicular to the windows and the entryway, the sofas face neither the windows nor the doorway, but instead are arranged to accept both vantage points.

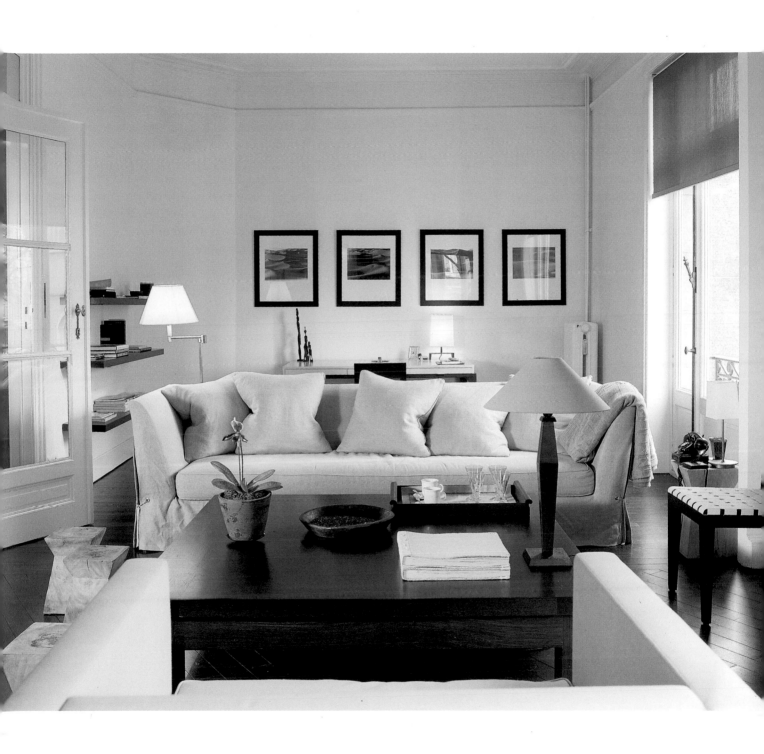

14. Don't ignore a spectacular focal point.

Kelly Wearstler: When I arrange furniture, I look to the shape of the room and the focal point. I like to create different conversation arrangements and little magical spaces for one or two people.

David Ling: Furniture depends on all these things: room shape, social interaction, traffic flow, and focal point. I like to collaborate with a client and choose the most important focal point.

Robert Cole/Sophie Prévost: Focal points do not have to be centered or symmetrically placed. Asymmetry is less predictable and gives dynamism to a space. Views are very important also, inside or outside the room. Study the views while using the room, and start from there.

John Chrestia: A focal point isn't always a view or a fireplace. It can simply be a wonderful painting. In any case, it should be considered a grounding point to be respected and referred to when decorating, but you certainly shouldn't arrange furniture around it. Obviously it's there; you needn't stare at it constantly.

Axel Verhoustraeten: It often happens that you have to choose between a spectacular view and a place to read. Curzio Malaparte complained of his famous house on Capri, "I built it in a place that is too full of nature."

Heather Faulding: I arrange around focal points. A split focus—a fireplace to one side of a room with a spectacular view across from it—offers flexibility and allows a room to have two different seating arrangements spelled out in furniture.

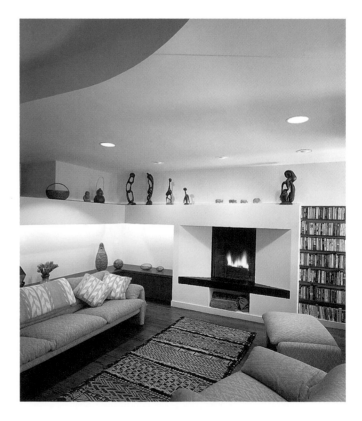

Heather Faulding keeps the fireplace as the focal point of this room. The simple arrangement of African art and the dynamic pairing of color makes this space perfect for a little light conversation or easy reading in front of a crackling fire.

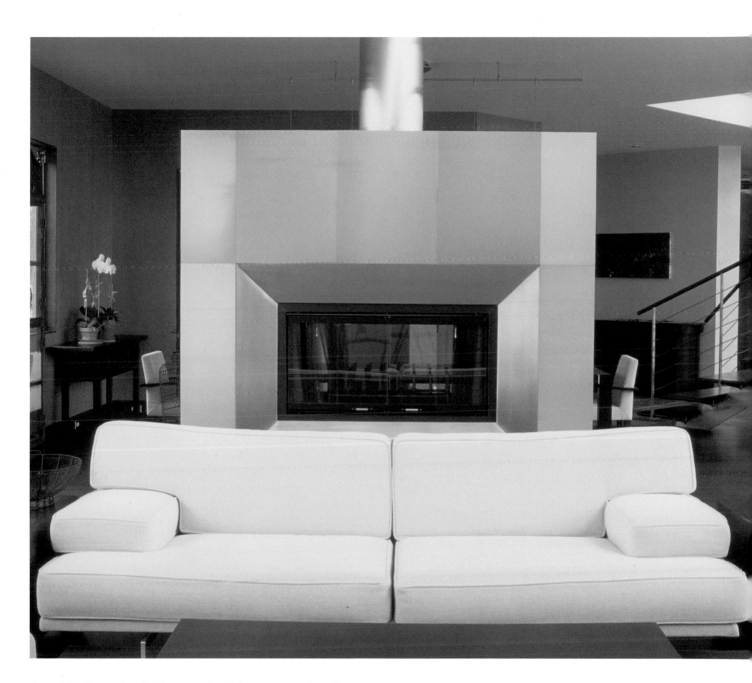

Smack in the center of this open-plan living room, a gigantic fireplace acts not only as a focal point but also as a room divider and backdrop for an equally oversized seating area. For Heather Faulding, a large element, centrally located, was a way to detract from the lack of spectacular views.

15. Be aware of scale and proportion among furnishings.

Laurence Llewelyn-Bowen: Proportion, as they say, is governed by the classical canon and has evolved over thousands of years to relate to the human body, so I think that it's dangerous to deviate from it. However, when it comes to furniture, I love playing around with scale, provided that it doesn't intrude into the use of the room. An overly large chandelier, a slightly squished-in swan-necked bureau, or a rather generous urn can be dramatic and grand. The same can be true for collections of tiny precious objects, which delight the eye with jewel-like detail.

Tanya Hudson: Be bold with proportions—make it really long and slender or really low and chunky—but don't be timid. Draw things up to as large a scale as you can to get a really good idea of the proportions before the item is constructed.

CLS Architetti Studio: For very huge spaces, like 18th-century rooms, you can use off-scale elements to reproportion the space. For example, in an ancient villa, we have designed a custom-made triple tub where a normal-sized one would have appeared too small.

Robert Cole/Sophie Prévost: No rules, no absolutes—whatever fits in the room. Trust your eye. We once saw the tiniest drawing room with the grandest, tallest, definitely over-scaled lounge chair, and it looked wonderful. It actually made the room feel bigger. We call it the *Alice in Wonderland* trick. Symmetry and asymmetry also need to be played off of each other, because too much of one or the other is simply dull. Remember that you don't have to have two identical items to create symmetry—you can achieve it with items of similar mass or general feeling.

Celia Domenech: A gorgeous selection of furniture can be ruined by a lack of good proportions.

Thomas Jayne: The trick to scale and proportion is learning the balance of large and small or an A-B-A balance of large pieces with small pieces. Too many things of the same size fails because it does not interest the eye.

David Ling: For me, scale and proportion are another way of saying "relationship." Size matters. More important, though, relationships matter. I think of proportion as a set of musical notes, because it's often musical how things relate to each other.

Charles Spada: A sense of scale is a talent in and of itself. Few people have the talent for scale. It seems especially lacking in furnishings bought off the floor. Consider when purchasing a sofa: Are the arms too wide or overstuffed? Too narrow and hard to the touch? Is the piece too deep for the room? Will I be able to put a coffee table in front of it without taking up too much traffic flow? Are the side tables too low or too high for the height of the sofa arms? Is the lamp too big for the table? Is the shade too short or narrow for the lamp? Can I see the neck of the lamp below the base of the shade? Should I put a grand piano in a space not really big enough for the smallest baby grand? Scale is about common sense, and good common sense dictates a well-scaled furniture plan—a must for any good scheme to succeed.

Kelly Wearstler: Change of scale in furniture is very important—large, medium, small, and short and tall. In a room that is proportionally successful, one's eye should frame up and down, then across the room.

Sometimes, one element that falls just out of proportion with everything else in the room is necessary to add design interest and a sense of whimsy. This works particularly well when the element is disguised in such a way that its style and color scheme fit perfectly with the room, but it appears simply as if it has expanded or shrunken, as Celia Domenech has done in this room. Whether it is a super-low coffee table, a teensy armchair or, in this case, a giant sculptural lamp, the effect is quick and easy.

Chapter Four: Windows & Lighting

If eyes are the windows of the soul, it seems fitting that windows are the eyes of a home. After all, they let in light and glow from within. It is this simple interaction, of light pouring inside and out, that gives the structure of a home its very life force. And so, these "eyes" and this "life force" cannot be taken too lightly—pardon the pun. In fact, almost every designer considers lighting, both natural and artificial, to be one of the most important elements of design. A flood of natural light is a prized commodity, and the play of light and shadows by a well-constructed lighting plan is akin to a highly regarded masterpiece.

16. Make a lighting plan.

Charles Spada: Without exception, there should always be a lighting plan accompanying the floor and furniture plan. A plan, for obvious reasons, is necessary to determine not only fixture placement, but also for convenient, sensible switching. Bedside lamps, as an example, should have switches not only at the bed but by the door as well.

Tanya Hudson: Lighting is very important and hard to get right. It is really helpful to do mock-ups if at all possible.

Thomas Jayne: There are too many ugly windows and unattractive lighting fixtures for sale, making it easy to end up with bad-looking combinations. It is hard to have a great room without proper window and lamp light, so you have to think about how they work together, not piecemeal.

CLS Architetti Studio: In our way of thinking, light, both natural and artificial, is always the core of our project. Therefore, we work with a lighting designer, and the project comes out together.

Robert Cole/Sophie Prévost: Lighting is essential. It is the most versatile tool we have for creating an atmosphere, even several, within a space.

Axel Verhoustraeten: Light and windows are essential, but they should not be planned. The site, perspective, orientation, and function dictates naturally where they should go.

David Ling: Once you get beyond the minimum task of lighting—allowing you to read or see what it is you are cooking—the art is being able to predict how a light source will actually feel once it's in your home. All the visits to a lighting showroom can't really duplicate your environment like the real thing. Windows and lighting aren't intimidating if you view them simply as sources of natural and artificial light. The art is in designing the emotional response to light.

Laurence Llewelyn-Bowen: As Claude Monet said, "Light defines form." For me, lighting is literally the fifth dimension. Rather than using a lighting plan, I advise the use of inexpensive table lamps to try out different lighting scenarios.

This kitchen designed by David Ling features stark white walls, a soothing slate floor, and rectangular windows, which not only let in a copious amount of light but also play on the rectangular tiles on the floor.

"There is much virtue in a window. It is to a human being as a frame is to a painting, as a proscenium to a play, as a 'Form' to literature. It strongly defines its content."
—Max Beerbohm, critic

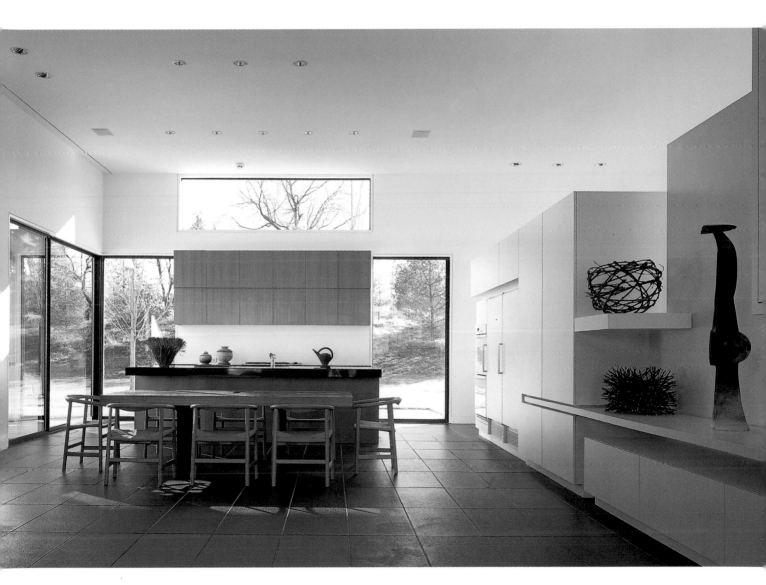

17. Leave a spectacular window naked (or nearly so).

Robert Cole/Sophie Prévost: A naked window can look very naked, unless it is a beautiful piece of architecture in its proportion and in the way it is detailed. Window treatments can be off-putting because they are traditionally such a strong presence in the room and usually very dressed up. The Modernists tried to get rid of them all together, which in the end was probably not a very practical solution.

Axel Verhoustraeten: In some countries, like Holland, curtains tend not to be used, whereas in others they are compulsory. If the architecture is interesting, as we hope it is, then a simple linen blind will be enough for the needs of privacy.

Laurence Llewelyn-Bowen: People are afraid of window coverings because the current vogue, a leftover from the 1960s obsession for Scandinavian design, is to maximize and worship available light. Bear in mind that the Scandinavians have light for only six months of the year, so we ought to be more relaxed. I personally am not a huge fan of large, naked picture windows. I like a view and, indeed, daylight, but in a circumspect manner.

Tanya Hudson: I tend to use a lot of mesh fabric blinds, which allow privacy but also give silhouettes of the view outside. They are nice, soft filters for a window. I guess they're the modern equivalent to the dreaded net curtain.

David Ling: Ideally, I like to use no window treatment at all. Secondly, I prefer the kind that you don't see when not in use. If you have to see it, then it has to be gorgeous, in which case, I favor simple but rich textures. The actual texture or density depends on whether it's used for privacy, light, or decoration.

Heather Faulding: Sometimes windows should be left naked. Large dramatic windows usually end up that way because our clients love the form, view, and light and just cannot bring themselves to cover them up.

John Chrestia: Not every window needs to be draped or covered. In fact, the naked window should determine how much covering it needs. An already elegant window may simply need a sheer curtain and an iron rod. If privacy is an issue, try adding a roll-down shade or theatrical scrim.

CLS Architetti Studio: Good views must always have naked windows. If the view is spectacular, then the window is not naked anymore.

In the case of this home, designed by John Chrestia, both the windows themselves and the view are spectacular enough to stand on their own. In fact, the very architecture of this living room bends to this wall of sliding glass doors and windows. Curtains, although needed at night for privacy, would only obscure this incredible expanse of transparency.

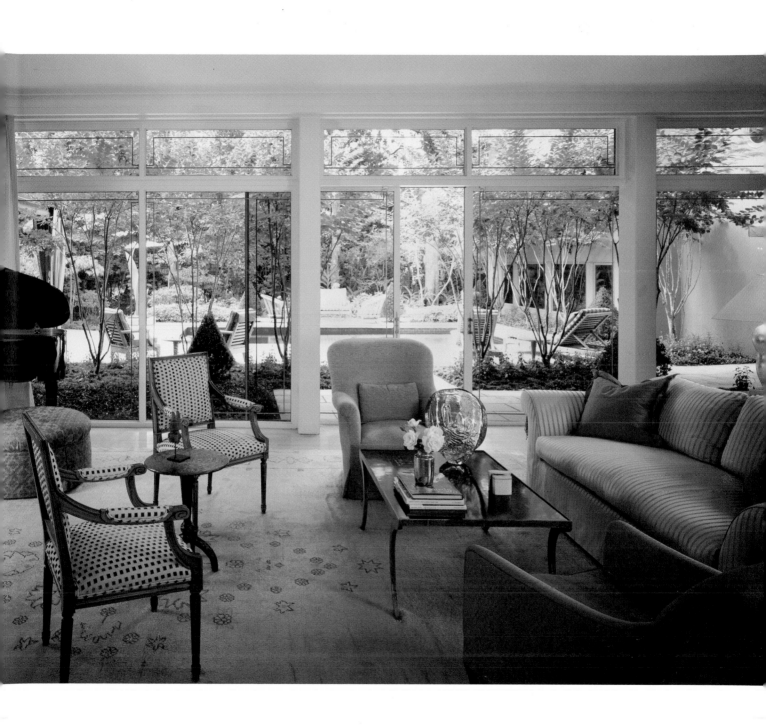

Chapter Four: Windows & Lighting 47

18. Keep window coverings simple and elegant.

Charles Spada: Consider the view outside the window and the light coming in. How beneficial is the light, and how beneficial would curtains be to the scheme? If there is a bad view, create an interesting window treatment. Shutters with a 2½-inch (6.5 cm) blade will easily adjust to allow light to flow in while blocking a view of a brick wall. Hung on simple hardware and flanked by simple, full-height curtains, shutters create a beautiful picture. Hardware should disappear, but what is in view should be in scale with the curtains. If curtains are to open and close, hidden rods, recessed into the back of the curtain rod, work the best. Drawing or opening curtains hung on rings can be a chore, especially if the curtains are long or of any weight. Curtain hardware with a painted finish should match the room trim paint color, making it unobtrusive.

Thomas Jayne: A window should be draped in response to its exposure and the architecture of the room. It depends on whether you are decorating a loft, a rustic country house, a beach house, a modernist house, or Georgian mansion. Sometimes a curtain on a wood or wrought-iron pole is too simple for a room's architecture. If a simple curtain does work, you can make your window more interesting by adding a painted pull-down shade. Fabric ultimately softens a room and completes a window, though I have done things like embroidered fabric pull-down shades and skipped the curtains entirely.

Robert Cole/Sophie Prévost: Drapes are a wonderful way to add color. We like simple window treatments. When privacy is not an issue and there is no need to use an opaque fabric, a simple sheer gives a wonderful filtered light and glow to the room. In some instances, we might layer one fabric or texture over another. Roman shades are more structured treatments and can look beautiful, especially when the window frame is deep enough for the shade to be set within it. Window treatments are important, both for the flexibility they allow for lighting, creating feelings of intimacy, and privacy, and also for the "dressing" of the room.

Kelly Wearstler: I love using fabric in all ways. It helps warm the room and soften the acoustics. I also like using a bamboo blind with a fabric treatment. Adding layers adds drama.

Heather Faulding: We like to use shades because there is often not enough room for curtains at the sides of wide windows. I'll admit that there is nothing nicer than the occasional piece of beautiful silk with a slight puddle—the crown could be large grommets on a pole or smocking.

Laurence Llewelyn-Bowen: I simply adore historical window treatments—swags and tail pelmets, festooned or draped window treatments—conceived and executed in plain, simple fabrics so that the architecture of the arrangement is paramount rather than a busy pattern.

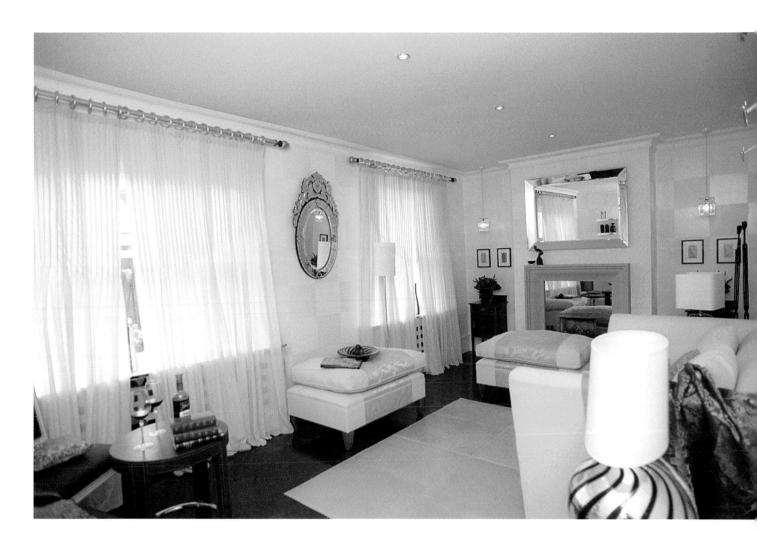

Simple sheer curtains drawn up with plenty of pleats and elegant hardware complete this room designed by Laurence Llewelyn-Bowen. The sheers not only highlight the enormous amount of sunlight pouring in, but the theatrical quality of these sheers pooling on the black floor also makes the window wall feel like a proscenium.

"A gem of a house may be no size at all, but its lines are honest, and its painting and window curtains in good taste."
—Emily Post, etiquette doyenne

Celia Domenech likes to keep window treatments simple. A selected fabric, whether it's translucent, patterned, or a woven solid, combined with curtain accessories made of chrome, wood, or bamboo are enough to complement a window. For bedrooms usually she uses white wooden shutters. If a darker room is needed, she uses side panels with blackout liners. For her, simplicity is the key. Many of Celia's ideas are illustrated in this Miami bedroom. Sometimes all you need is a simple sheer in a fabulous fabric to create all the necessary softness, privacy, and interest. Of course, the addition of wooden blinds is necessary in this case for modulating the light and privacy, but in white on white, they practically blend into the window, allowing the sheers to take center stage.

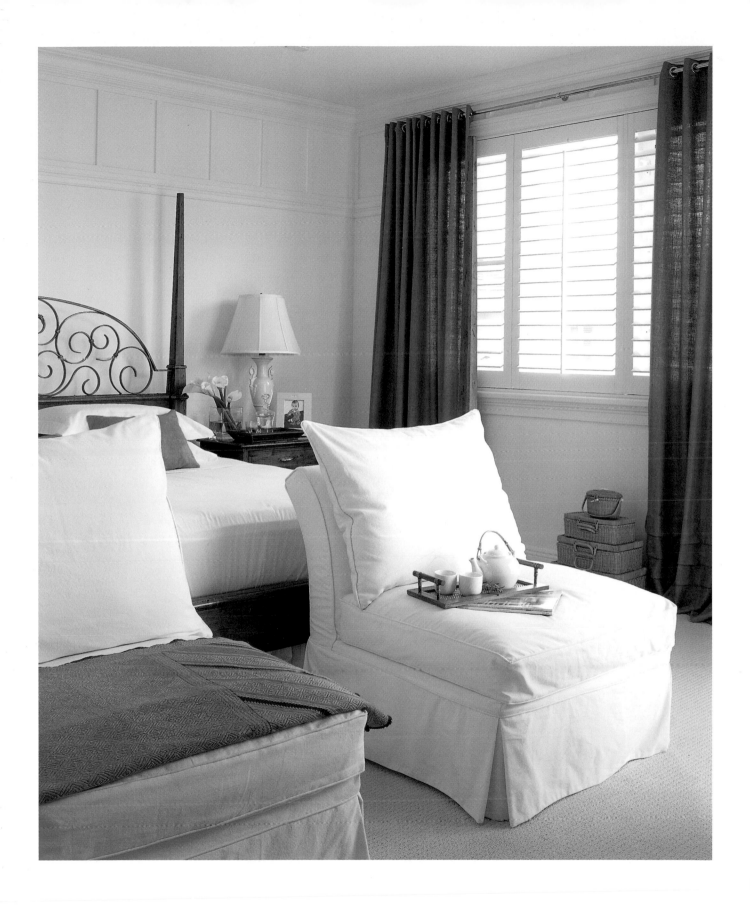

19. Your lighting plan should have variety and be adjustable.

Thomas Jayne: Remember that you are balancing light from above, from mid-level—table lamps, floor lamps, and sconces—and even from below—uplights. Table lamps give regions of a room, such as seating areas, a nice glow.

CLS Architetti Studio: We use lighting in the form of colored washes, dappled patterns, and projections as a type of artwork. They are not only functional but also beautiful, and, of course, dimmable, so you can have all the different shapes and tones of the light and colors.

Tanya Hudson: The lighting plan is crucial. It is best to have some areas of darkness and shadow because it helps the lighting appear much more interesting.

Robert Cole/Sophie Prévost: It is important to have various sources of light to have the flexibility to create pools of light and shadow. Try to mix different types of general lighting—downlights, pendants, and sconces—with task lighting, such as table lamps. Whenever possible, install dimmers for your light fixtures. It is a very simple, inexpensive, and powerful tool that allows you to easily alter the qualities and uses of a given area.

Charles Spada: Lighting should be well designed at the beginning stage of a project. Used judiciously, uneventful contemporary recessed lighting, combined with wall-mounted lighting and ceiling fixtures, offers both good light and an eclectic mix of fixtures.

Celia Domenech: Mixing different types of light allows you to have different atmospheres in the same room just by pressing the switch or adjusting the dimmer. Different sources of light also enhance a space.

The variety of lighting sources in this kitchen designed by the team of Robert Cole and Sophie Prévost allows for a changeable space that can serve as either a work space, gallery, or dining area. Recessed can lights in the ceiling create pools of dimmable halogen light directly onto the floor, whereas the same type of recessed fixture, used with a wall washer, creates arcs of light on the artwork and the black cabinetry.

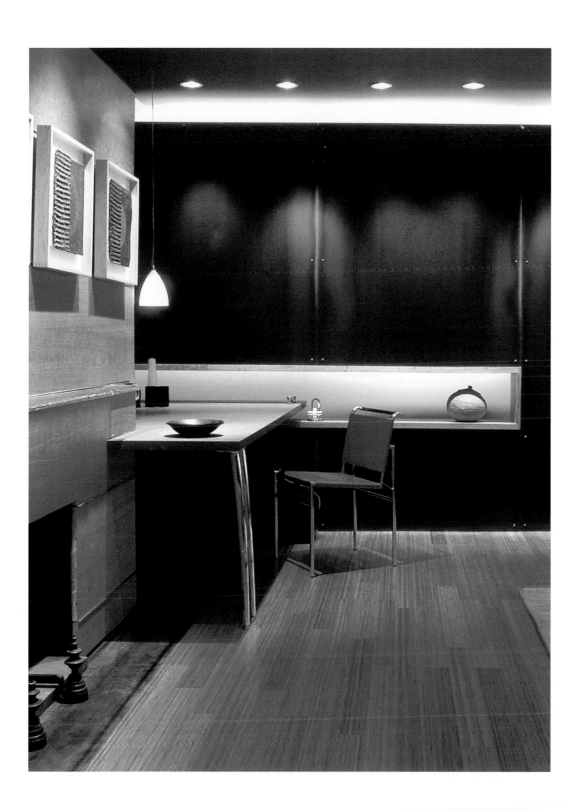

20. Indirect lighting is always better than direct.

Laurence Llewelyn-Bowen: The key to good artificial lighting is to create several flexible lighting scenarios to encompass task lighting, mood lighting, and those romantic moments. Always light the corners of the room; never illuminate from a central point.

Heather Faulding: Use reflected light as much as you can. We try to light ceilings and objects, special structural elements, and whole expanses of wall. Most architectural lighting is hidden. Decorative lighting is mostly just that—important, but not the main ingredient.

Robert Cole/Sophie Prévost: We avoid using bright, general lighting coming from one central source in the room, such as a chandelier or a mounted ceiling fixture. It gives a uniform, uninteresting quality because it does not provide contrasts. It is great for house cleaning, though.

Tanya Hudson: It is always better to reflect light off a surface rather than simply lighting air. It will animate that surface and give a gentler pool of light.

David Ling: I like ambient lighting to be from hidden sources, like indirect lighting coves. Downlights are necessary evils when the room is too deep for indirect lighting to reach.

Charles Spada: Interesting architectural details should be well lit, as should good art and collections. Wall washers are great where illumination is necessary to bathe walls in soft light. To avoid a commercial look, the smaller the recessed ceiling fixture, the better. Table lamps provide a soft, personal light, as do candles in the appropriate areas of a room, lit at appropriate times.

Kelly Wearstler: It is the light in a room that can make a person look great or not so great. Make sure downlights are not directly overhead—it can create raccoon eyes. I love chandeliers, sconces, and lamps for sexy rooms; they are sure to make people look good. Of course, dimmer switchers are a must.

Sconces, turned upward, act as dramatic lighting for this special dining nook designed by Boston designer Charles Spada. For a space that uses primarily natural light or candlelight, there was little need for an overhead flood of light. Instead, the designer used a candle and lantern set across from a mirror to catch the flickering and these uplights for added drama and atmospheric lighting.

Chapter Five: Bricks & Mortar

This chapter was originally called "Nuts and Bolts," but that seemed a bit outdated and too *This Old House* for a book about decorating. However, there is so much to cover when it comes to walls, floors, and ceilings, and much of it revolves around building materials and the nitty-gritty (yet another possible chapter title) elements of decorating: paint, floor tiles, concrete, and a whole list of new and natural alternatives. These are truly the basics, and although some of these ideas may not be for DIY-ers or those short on cash, they form the foundation (and surface area) for good design.

21. Don't forget about surface areas—walls, floors, and ceilings.

Charles Spada: Cracked or sagging ceilings and poor walls can benefit from a layer of wall canvas applied to the surface like wallpaper before painting or papering.

Robert Cole/Sophie Prévost: We have never understood the "rule" to paint ceilings white. Because it makes the room feel taller? This isn't always a good thing. We paint ceilings the same color as the walls or a shade or two lighter. When painted the same color, a ceiling doesn't look darker than the walls. It makes the room look more complete. Certain rooms gain from having dark ceilings, such as powder rooms for the intimacy it creates and dining rooms where it is interesting to bring down the scale of a room where everyone is usually sitting.

John Chrestia: The treatment of ceilings really depends on the style and period of the home. Ornate ceiling and cornice moldings can be treated in several ways. In my 1850s New Orleans townhouse, I made these decorative touches look contemporary by painting walls, ceiling, and moldings all the same flat color. It looks as though the ceiling is carved out of chalk. For a more glamorous room you may want to highlight such embellishments with paints that add glitter and sheen.

Thomas Jayne: Many people forget about the ceilings, but sometimes a light tint of a shade breathes life into a room. I also like mirrors for ceilings—colored mirrors that shimmer and play against the light.

David Ling: I look at walls as sculptural opportunities. Carving openings into a wall and varying the flat surface with niches and shelves integrate display and storage, while turning the wall into an exciting composition. Floors set the tone of the design. We typically use one material throughout to emphasize flow and expand the space. The selection depends on many issues: the way it absorbs light, its durability, and its warmth. I like to select conventional materials with a twist, like wood floors laid in an interesting pattern, or unconventional materials, like glass for floors.

Heather Faulding: Paint a carpet on the floor, or just a pattern—traditional or contemporary. You can inlay carpet or tile in areas to change texture.

Kelly Wearstler: Don't forget the option of applying a high-gloss paint on your floors. Do something unexpected with ceilings—add wallpaper or a high-gloss, brightly colored paint with contrasting moldings. Remember, there are no rules!

John Chrestia: Floors are obviously an important design element—whether it's parquet de Versailles or polished concrete—adding huge amounts of interest to a room. Walls can easily be made more interesting with fairly inexpensive coats of paint and accent lighting that washes a brightly saturated wall with light. More simply, artwork can add more drama and style than even the most spectacular moldings.

"To me, a building—if it's beautiful—is the love of one man. He's made it out of his love for space, materials, things like that." —Martha Graham, choreographer

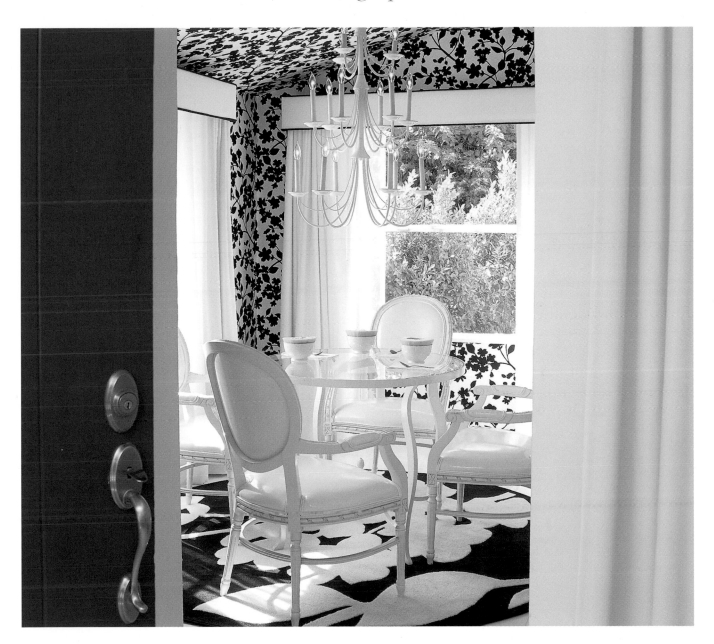

For a dining area that pops with dramatic design elements and unexpected touches, try doing what Kelly Wearstler did with this black-and-white dining room. By papering all the walls and the arched ceiling in the same wild wallpaper, she set the stage for unexpected fashion. Add to that an all-white dinette set upholstered in white patent leather, a triple-tiered chandelier, and a rug that appears to be a close-up detail of the wallpaper—the result is pure style.

Use natural materials and renewable resources.

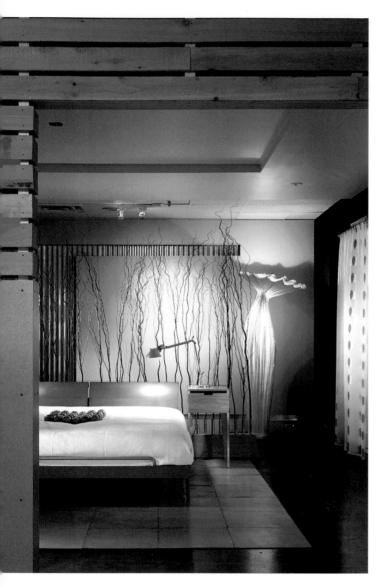

The leather tiles on the floor of this bedroom designed by ColePrévost for a Washington, D.C., show house are offset by the black concrete underneath and the corrugated aluminum wall behind. Combining contrasting elements, like the natural materials of the "willow wall" headboard and warm woods, with industrial materials, like aluminum and concrete, is this firm's specialty.

Heather Faulding: We try to use renewable resources as well as salvaged wood and lumber as much as possible for both decorative and structural elements.

Robert Cole/Sophie Prévost: Bamboo is as hard as maple flooring and is a renewable resource. Bamboo trees mature in just 7 years, so it's an environmentally sound material. Cork tiles are great in a kitchen, as they are softer than ceramic tiles or stone. After being treated and sealed with urethane, they're easy to clean. Leather tiles are another fabulously luxurious material; they feel great underfoot in a bedroom, and they age beautifully when maintained by waxing and buffing.

Tanya Hudson: Leather flooring is a great replacement for fitted carpets. It's softer and warmer than wood and far more attractive than traditional carpet, although it is rather expensive.

Kelly Wearstler: For floors, cork is a great material with lots of texture, and it's also great for sound. Cork is great on a wall for noise control, too.

Thomas Jayne: Cork is an undervalued material for floors—it's soft and renewable, and it looks great.

Celia Domenech: I love pairing the texture and warmth of bamboo flooring against the refinement and coldness of plain marble or limestone. For a cozy room, like a library or den, a leather tile combined with wood is another good option.

Charles Spada: I still love beautiful stone or wood floors kept in the simplest, classic patterns: herringbone, running bond, diagonally laid stone with contrast inlaid, cabochons, and borders.

23. Don't eliminate the option of industrial materials.

Heather Faulding: Definitely explore industrial materials because they are so often the simplest and the strongest—stainless steel, poured concrete, and even plastics and laminates.

Robert Cole/Sophie Prévost: Stained or dyed concrete is a great way to inexpensively introduce color and depth for floors and countertops. Sheets of metal laminated directly to the wall can be incredible. We've used copper, hot-and-cold rolled steel, and galvanized steel. The key is finding the right finishes.

Tanya Hudson: Rubber or vinyl flooring is a good product for bathrooms. It is warm underfoot and more fun than traditional tiles. Rubber must be sealed first; otherwise, you get white, cloudy marks on it. Vinyl is very cost-effective, and there are loads of colors and textures available. There are even some great metallic colors.

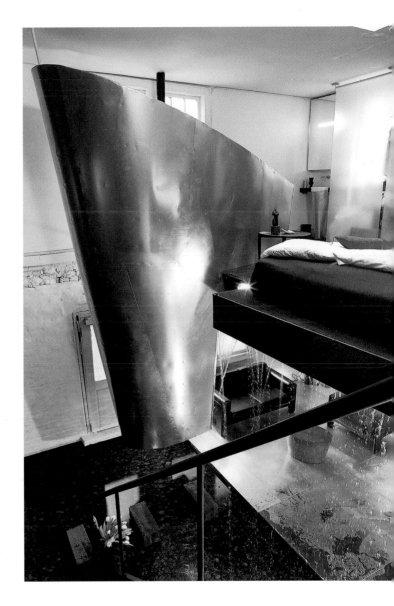

For his New York City loft office space, architect David Ling created this conelike sculpture out of bent steel to command the center of the two-story space. Rising up like a hot-air balloon, the sculpture feels futuristic yet serene. Ling, who incorporates many Eastern elements into his designs, matches the coldness of the steel with a floor made of worn pebbles.

24. Try interesting paint finishes and decorative wall treatments.

Kelly Wearstler: For walls, anything goes! Add millwork. Paint all the walls a great color—but be sure to use a high-gloss finish. Wallpapers and fabric-covered walls are another often-forgotten option.

Robert Cole/Sophie Prévost: Venetian plaster, the most labor-intensive faux finish, has a wonderful depth and patina. As for paint, the state of the walls are the clue for determining which luster to use. We have been playing with various waxes to create the illusion of more radiant depth in the wall finishes.

Celia Domenech: For wall treatments, I like the velvet look and touch of the satin paint. I would use a high-gloss finish as a statement for certain areas. I also like wood and leather paneling on the walls.

Thomas Jayne: Paint finishes, shiny or flat, are specific to the room. But remember: a glossy finish projects a subtle light back into a room, so use it to its fullest potential. Decorative painting adds texture and interest. Even doing just a baseboard or molding with a decorative finish could enliven a room.

Tanya Hudson: Decorative finishes are fine if they're done well. There are two-pack paint products available that anyone can use to create the look of an expensive plaster finish with variations in color, dimples in the surface, and varying levels of gloss and matte—they're great.

Charles Spada: Soft, matte faux finishes can help detract from walls in poor condition, but I would keep faux painting to a minimum—and only the best—in unexpected places, like the interior of a bookcase. I also like shiny surfaces in dark colors on smooth walls for small, intimate spaces.

The striated chocolate brown walls of this den were given special treatment by designer Kelly Wearstler. Upholstered with raw silk fabric, the added sheen and texture creates an even greater feeling of softness and comfort.

25. Add softness and pattern to walls using fabric and upholstery.

Charles Spada: Upholstered fabric walls—especially on walls in poor condition—are good sound insulators with a womb-like effect, which is especially comforting in a bedroom or library where you want to feel surrounded by quiet and softness. You can also get paper-backed ultrasuede cut into rectangular blocks, which mount like wallpaper.

Laurence Llewelyn-Bowen: We as a generation of designers have not utilized the full potential of the patterned interior. It brings glamour, sophistication, and elegance to the home and strikes a brave pose to deflect the onset of 21st-century urbanism, which I deplore in the domestic interior.

Tanya Hudson: I really like padded vinyl on walls in a TV room or music room. It's good for sound and heat insulation, and it's cheap and washable. There are lots of new suedette fabrics on the market, some thin enough for curtains. These have a great feel, and again, they are washable and perfect for walls and upholstery.

Thomas Jayne: Upholstered walls are very luxurious. We have made several leather-walled rooms. I once did a bar/lounge-type room with leather placed on panels with brass upholstery tacks along the edges.

Heather Faulding: Noise control is best gained with upholstered wall panels and as many absorptive materials as possible: rugs, tie-back drapes, and upholstered furniture. Upholstered walls are also a great way to hide uneven walls.

John Chrestia: For softer and cozier environments, consider upholstery on the walls of a small room, such as a library or study. It can also add texture to larger rooms.

In this spectacle of a bedroom, Tanya Hudson applied folded layers of natural-colored linen to the walls. Behind each layer is a strip of lights that can change color, from red to pink to white. The headboard and upholstered wall becomes more like a light sculpture and allow this room to go from cozy to cocoon.

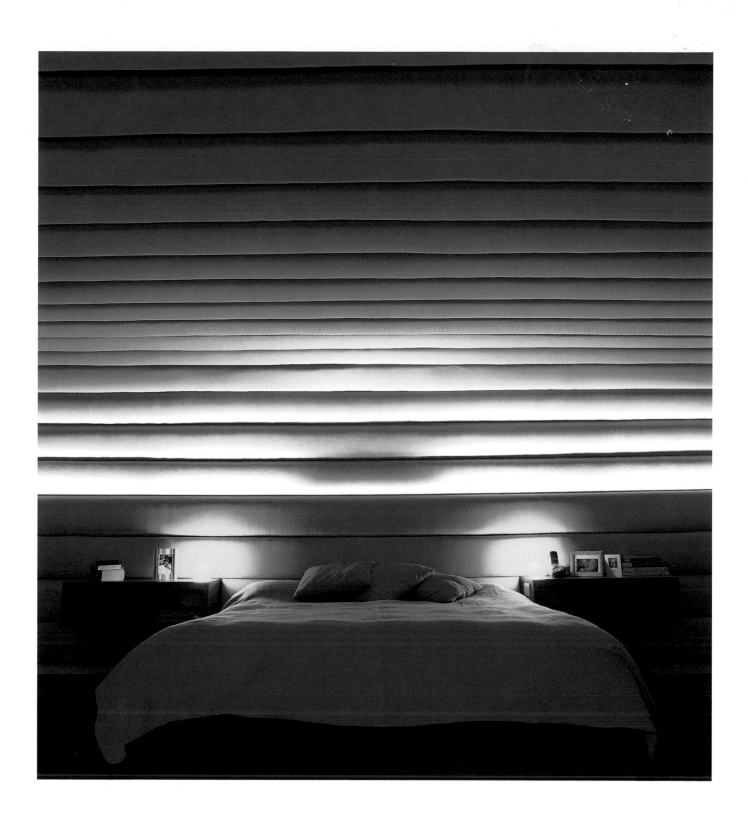

Section Two

Habits for Every Room

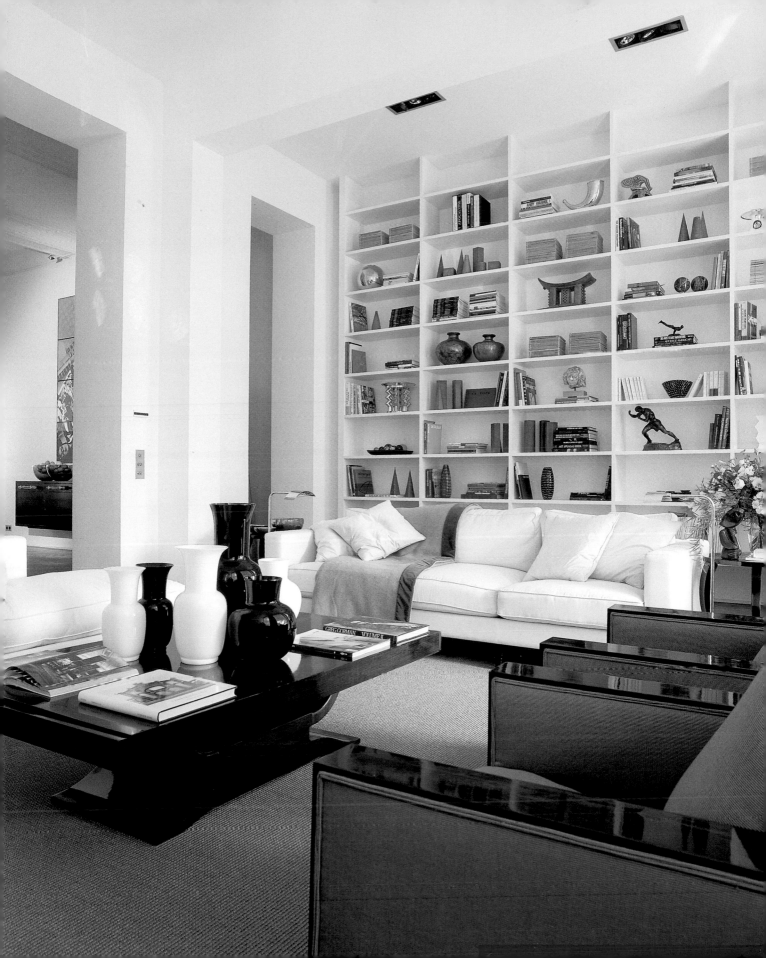

Chapter Six: Lovely Living Rooms

Traditionally speaking, living rooms were meant to be a showcase—the usually off-limits room where you would direct visitors and entertain guests. In more recent times, the role of the living room has "morphed" into something more versatile and informal—a place to watch television, lounge with a cup of coffee and the newspaper, or simply hang out with your friends and family. The functions of living room, den, and television room have come together under one ceiling, and now the trick is making it comfortable, stylish, and functional for each of these roles. The designers agree that comfort, conversation, and convertibility are the most important elements to consider when designing your living room.

26. All living rooms should be comfortable, accessible, and flexible.

Robert Cole/Sophie Prévost: Comfortable furniture and a flexible arrangement are a must. Three- and two-seat couches along with lounge chairs allow for more flexibility than a sectional or L-shaped sofa. The feel and texture of the upholstery are important: This is a room where one lounges, so it ought to be a peaceful room, a place of repose.

Celia Domenech: Inviting and relaxing, that's what we look for when we go home. The space has to suit the owners' habits and needs. They'll maybe want a chaise for reading, a table for a home office, or anything else that meets their lifestyle. Living rooms nowadays combine all sorts of usage. It's a place where families get together with children and friends more often. My main focus is to create an area that is comfortable but, at the same time, chic and attractive.

CLS Architetti Studio: Comfort is the key. Your living area should be transformable and flexible so that you can be comfortable in many different settings—by yourself, for privacy, for entertaining, and for small groups.

Laurence Llewelyn-Bowen: There's been much lip service paid to the concept of "zoning" in large living rooms recently. For me, this is no revolutionary concept. The best way of dealing with a large space, as practiced in large country houses, is allowing for a variety of activities, some possibly "private"—screens are a must—in the same environment.

Charles Spada: Living rooms should always have two or more smaller areas so that more than one conversations can take place.

Tanya Hudson: A living room should be very comfortable. Although wooden floors with no rugs look stunning, they are very difficult to lounge around on, and these days, people like to sit on the floor and rest against the furniture. Soft surfaces also work better with sound for listening to music or watching movies.

"I like all the chairs to talk to one another and to the sofas... not those parlor-car arrangements that create two Siberias."
—Mario Buatta, interior designer

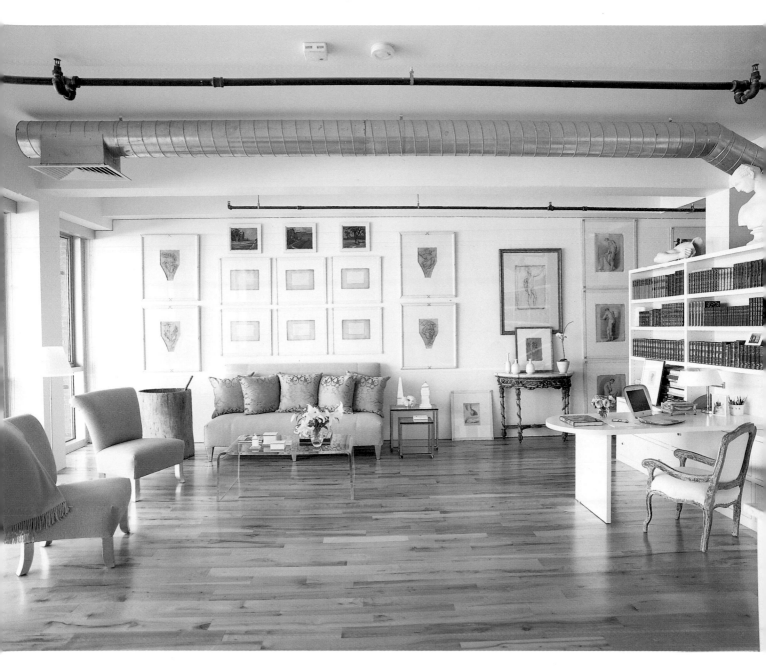

This versatile living area designed by Charles Spada can be used for several functions. It's formal enough, with its suite of elegant furniture and antique accents, to be used for entertaining, yet it is also open and casual enough to be a multipurpose, everyday space for lounging, working, and casual visiting.

27. A living room should be formal enough for entertaining but never fussy.

Thomas Jayne: Most modern living rooms need to double for the occasional fancy party and informal entertaining, so the room needs to look attractive and dressed up. To dress it up, consider fresh flowers, additional accessories, and durable, no-silk taffeta for upholstery. But even the fanciest rooms should be conducive to a casual conversation.

David Ling: If the location of the living room is close to the entrance, include some of the materials and details found in the entrance to make the space feel more public for entertaining. Also, ample daylight, views, and glass enhance the entertaining aspect of a living room.

Robert Cole/Sophie Prévost: It shouldn't be a room for "show." It needs to reflect you, or at least a part of you. It ought to be used by family and friends and be comfortable. Although it can be more formal than the rest of the home, it should not be a museum.

Kelly Wearstler: Living rooms should be one of the most special and glamorous rooms in the house. If you are going to spend a little extra money, do it here. In creating a living room as a private space as well as a space for entertaining, you need to make sure that the furniture in the room is versatile.

John Chrestia: If you want your living room to play double duty as both an entertaining space and a private family room, it has to be able to go both ways— dressy and casual. Stay away from too-dressy fabrics, like damasks, but don't go with something overly casual like a nubby chenille. Stick with versatile linens and lightweight silks.

Charles Spada: Living rooms should be more formal than a family room—comfortable and lived in, but not just another TV room. Lighting should be soft, and ideally, the space should open up to the outside, be it to a screened-in porch, terrace, or garden.

Laurence Llewelyn-Bowen: I have to say, I truly dislike living rooms that act as areas designed solely to illustrate the occupier's wealth or social standing. For me, decorating to subjugate was all well and good in the 19th century, but society has moved so far beyond the feudal days of "them" and "us." If a living room is used principally for the reception of others, then it ceases to be a living room and remains merely a soulless reception room. Living rooms should be layered areas that integrate special memories with practicality, all held together with the glue known as taste.

"One must never view living rooms as being ceremonial rooms where the art of entertaining and living is different from other rooms, " says Axel Verhoustraeten A classic furniture arrangement, enhanced with a formidably displayed collection and a touch of fresh flowers, makes this living area appear to be ready for guests. It's also subtle and chic enough to not seem contrived for company.

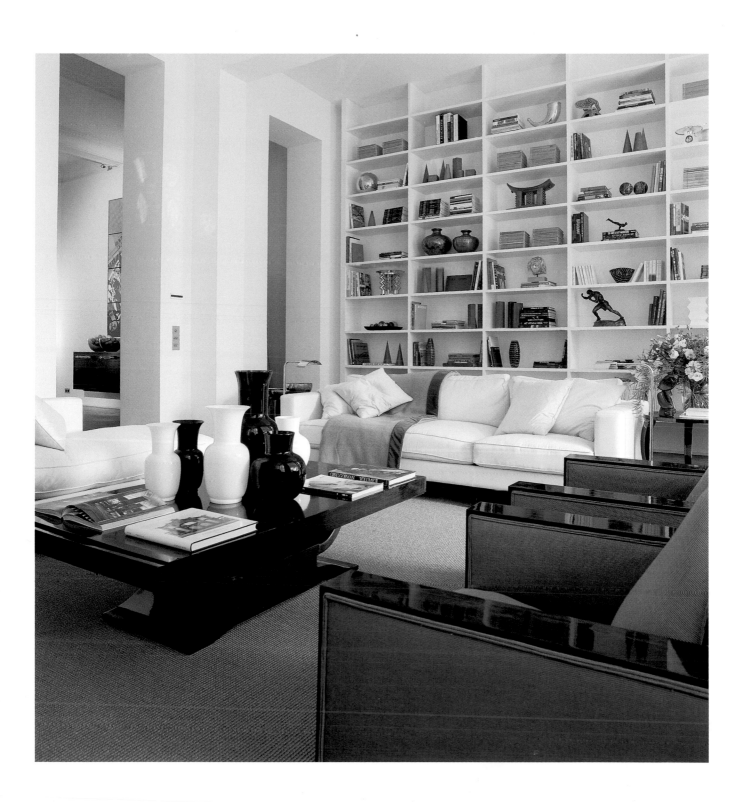

28. Living rooms should be personalized and reflect the owner.

Thomas Jayne: Public rooms in private houses should reflect the owner through the taste of the furnishings: the choice of works of art, the fabrics, and perhaps a few objects with personal associations, say, an engraved box or a small group of family pictures. The best rooms have a refinement of taste without the burden of many personal mementos. By the way, this is not the first choice for a location to hang family portraits— they look better in libraries, studies, or bedrooms.

Kelly Wearstler: Fabulous accessories, lighting, and down pillows enhance the personalized feel.

Robert Cole/Sophie Prévost: Cozy furniture and a warm, "cocooning" color on the walls and ceiling make any room more intimate. Of course, personal artifacts are very important. It is nice when a living room has a little piece of everyone in the family through photos, artwork, and odd finds associated with special stories. It is important that our homes reflect who we are.

CLS Architetti Studio: I really like to mix old— maybe heirloom—soft down sofas with classic styles from the 1960s, along with contemporary styles. Designing a seating arrangement like this is a good way to personalize your living room. It shows your various inspirations, background, and culture—it represents your personality.

John Chrestia: For a personal touch, I love a baby grand piano in the living room. It's a sculptural element as well as a functional one. Even if you don't play, have someone else play it at parties. If a piano is outside your budget, consider introducing a game table or even a library table topped with some books to help add life to the room.

David Ling: Decorative objects, the scale of seating, and the arrangement of furniture are all ways of bringing a larger public space down to a human scale. Intimate lighting, niches, and quirky heirlooms also lends a personal identity to the space.

Using artifacts to personalize the space, Robert Cole and Sophie Prévost were able to add life and an identity to this spartan living room. The overall atmosphere is casual, with the rough-hewn tables and low seating, but the addition of dramatic lighting, wall treatments, and artwork give it some personal drama.

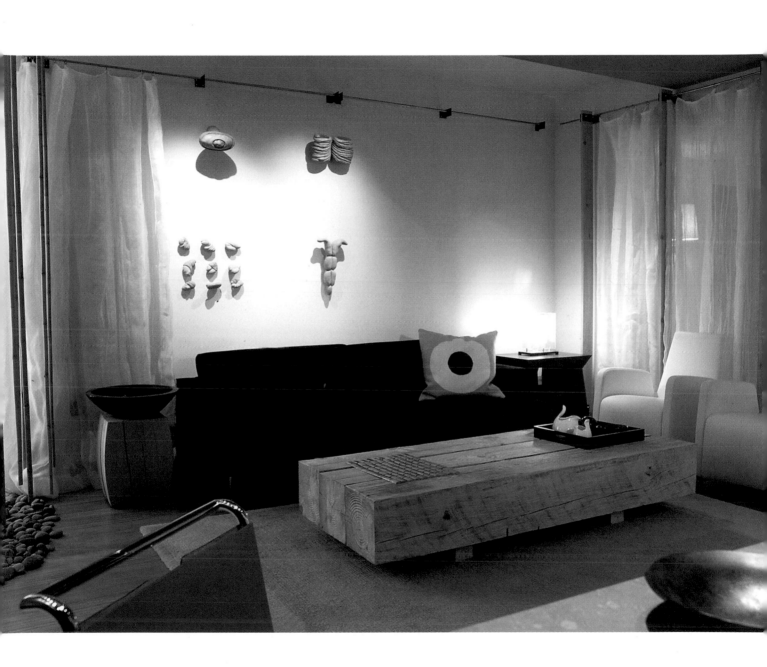

29. Keep your television disguised or unobtrusive.

David Ling: There is always the question of the television versus the fireplace versus the view. I think TVs should be seen when in use and unseen when not in use. Although the flat-screen TV is a vast improvement, I think everyone should have the option of concealing the TV.

John Chrestia: I really dislike exposed televisions. If you don't have the space for a separate media room with built-in cabinets, you should hide all your electronics in a nice-looking cabinet, or even an existing armoire or buffet.

Heather Faulding: Televisions can live in living rooms. They can become art or be made to disappear. If they are a big part of life, design them into the cabinetry or paneling so that the screen is flush with the wall. If the TV is truly abhorrent, you can hang a painting over the television with a hinged frame. Flat-screen TVs are so attractive these days that they can look great on their own.

CLS Architetti Studio: We like to integrate media components not only for fun and entertainment but also as part of the decor. We work with a computer science facility to design projectors that are part of the architecture of the house. For example, we'll use a wall of sandblasted glass or a sheer curtain as a screen on which to project everything from the news to a computer screen to artwork. It's so flexible, and there's no end to how much you can do with this type of design technology.

Laurence Llewelyn-Bowen: Twenty-first-century entertainment stems from hugely dull, little black boxes. TVs, DVDs, stereos, and the like are, for me, a necessary evil, but thankfully discreet enough to incorporate into bookshelves with plenty of interesting objects to draw the eye away from those little black monsters.

Axel Verhoustraeten: One must respect the lines in a room without it becoming a temple to technology.

Charles Spada: The entertainment center of a home should be in a separate family room whenever possible. When that's not possible, all television and music components should be housed in quality built-in units—floor to ceiling, wall to wall—so that the storage becomes one with the architecture of the room. When possible, I try to incorporate bookcases as part of an entertainment unit. They're an integral element in a successful living room scheme.

Kelly Wearstler: I prefer a unit that is totally designed for media components with the notion of change due to today's technology. Don't forget to include space for tons of storage. Remember, always have adjustable shelves in a unit like this—technology is always changing.

Robert Cole/Sophie Prévost: Hide all your electronics. There is nothing more unsocial than walking into a room with a monster TV in the center of it. The stereo and TV do have their social place and role—as background servants, being heard as necessary and seen only when desired.

Celia Domenech: A built-in wall unit offers flexibility to show or hide audio and video equipment. Sliding screens made of sandblasted glass and stainless steel, or any other combination, could be a good solution to cover a TV placed in the living room.

This sleek, contemporary living room maintains a clean, uncluttered atmosphere, despite the number of media components in the room. By incorporating the television and stereo into a built-in bookshelf, designer Celia Domenech framed the electronics in a contrasting white storage unit that makes the television feel like artwork.

30. The height and size of living room tables is as important as their style.

Celia Domenech: I usually use low to standard-sized coffee tables that allow me to accessorize with taller elements that in the end are not going to compromise conversation. This is not a rule. Tall coffee tables can make a statement, too.

Robert Cole/Sophie Prévost: A coffee table should be lower than the seat. Very large coffee tables are wonderful. They negate the need for side tables because everyone has a chance to put their drinks in front of them. They also provide a great opportunity for displaying wonderful objects and arrangements.

Charles Spada: As for coffee tables, I prefer tea-table height in a room with high ceilings. Tea tables with a height of 24 to 28 inches (61 to 71 cm) are a good balance to 18 to 19 inch (45.5 to 48.5 cm) seating height. If you want a standard coffee table, I prefer larger ones, like a 4-foot (122 cm) square table.

David Ling: Generally, I like the coffee table low, no higher than the seat.

Tanya Hudson: I prefer coffee tables to be large and tall—less distance to carry your glass of wine or lift your TV dinner—but for the proportions to be right, they should be quite big. I like a coffee table to be something like 15 ½ inches (39 cm) high and 47 inches (119.5 cm) square.

CLS Architetti Studio: I don't like traditional coffee tables. Instead, I like a big daybed or an oversized ottoman close to a sofa, where you can put plates and books and such. As for putting glasses down, I like little side tables sprinkled throughout. Or why not just place them on the floor?

John Chrestia: We always use a sizable enough coffee table for drinks and appetizers or for books and candles—these youthful elements make the room feel lived in.

Kelly Wearstler: I prefer sitting a bit on the lower side—16 to 17 inches (40.5 to 43 cm) seat height. For coffee tables, large, low coffee tables are great. Or you could use a higher coffee table, like a 17-inch (43-cm) sofa seat height with a smaller-sized coffee table that is 24 inches (61 cm) high to create a nice layering effect.

Laurence Llewelyn-Bowen: Coffee tables are a 20th-century invention, though not one of the 20th-century's greatest achievements. I much prefer a good sprinkling of occasional tables around the seating arrangement, possibly a sofa table behind one of the sofas with a pretty lamp or floral arrangement.

Thomas Jayne: High tea tables make a living room feel more formal and old-fashioned. Large, low coffee tables that are durable and allow you to put your feet up immediately relax a room.

An unexpected assortment of table heights and sizes in Thomas Jayne's own home offers inspiration for abandoning the classic coffee table ideal. By pairing something tall enough to eat off of with smaller cocktail tables at the sides of chairs, Jayne has created a versatile conversation area.

31. Let space and function define the arrangement of furniture for living rooms.

Heather Faulding: Generally, in contemporary designs, I prefer low seating and tables. Each room predicts the arrangement of furniture, as do the pieces that you have. For example, an antique requires a different setup than something more modern.

Celia Domenech: When studying the arrangement of furniture, I look for larger couches, some extra seats that are not so visible, like benches, under or beside a coffee table or a console, and side tables. Mainly, the living room has to be a balanced and enjoyable place. Keep in mind that the energy in the room needs to flow. I don't create crowded rooms where instead of walking through you have to jump over the furniture.

Robert Cole/Sophie Prévost: We aren't wild about forced or extremely formal arrangements. They feel stiff and contrived. Loose, relaxed, and casual are the goals. One of the things we try to do is keep the conversation open. We avoid closed arrangements of furniture to allow for the addition of another person or for a piece of furniture to be pulled into a grouping. This flexibility keeps the spaces from feeling too formal. We do this by using L-shaped layouts, often with two orientations, such as views or a key focal element, like a fireplace or significant piece of art.

Charles Spada: All seating should be comfortable and practical; beware of uncomfortable antiques. Something old is a must in most design schemes but not as upholstered pieces. Sofas, for example, should be contemporary—new, but not necessarily modern in design—well constructed, and cushy. Living-room furniture should be artfully arranged to accommodate people in various conversation areas—by a fireplace, an exterior view, a piano—at the same time.

Kelly Wearstler: It is important to have a couple of large comfortable pieces and, at the same time, have smaller pieces that can be moved around for entertaining. Set up areas for small groups to sit, lounge, and chat. Screens and draperies are great for enclosing areas and making a room feel more private when it's being used by just one or two people. Also, you can use large pieces of furniture as space enclosures.

David Ling allowed the space to dictate the furniture setup. The expansive window and sculptured fireplace are the focal points of this living room, and the conversation area, though traditional in its layout, pays homage to the view. Few accessories or flashy colors distract from this primary focus.

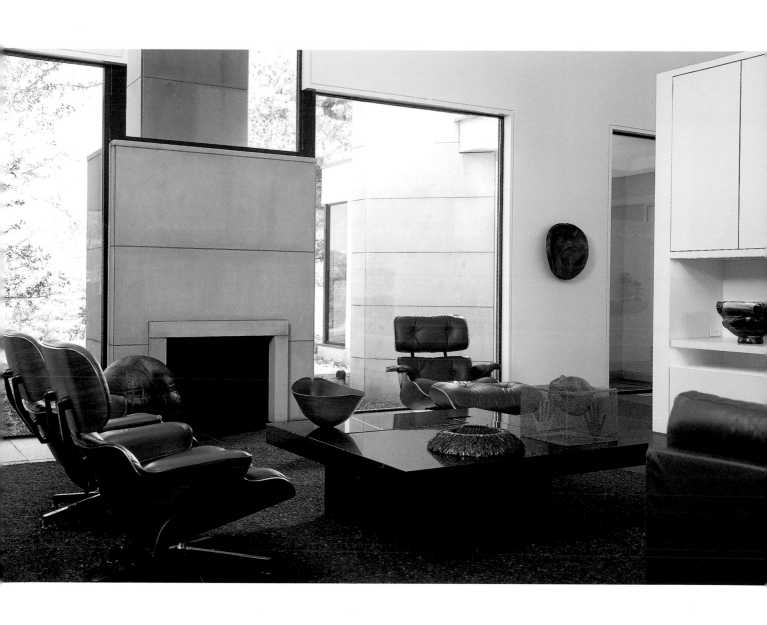

Chapter Seven: Bedroom & Bath Basics

Bedrooms and bathrooms are, at the very least, private rooms to be decorated with personalized style and comfort in mind. At best, however, they are our very own sanctuaries, a retreat to which we can retire when the rest of the world—and the rest of the house—seems to require too much. The same goes for designing the perfect bedroom and bathroom. Although it may take some extra planning to decide where the bathroom lighting should be placed or how much space your wardrobe will need, the rest of the space is yours to fill. These are the rooms that allow you to indulge in your most sybaritic luxuries or simply to answer your minimalist tendencies with only a clean, modern bed. No one else has to use these spaces, so it's really all up to you.

32. First create a relaxing atmosphere.

Heather Faulding: Bedrooms should feel calm and serene, and they should cater to your nighttime needs.

Robert Cole/Sophie Prévost: The feel of the room has to be decided on first, so we usually begin with the color scheme, the mood. We found that the dressing of the bed can then be made from any material we choose to complement the color scheme.

Celia Domenech: Make the general ambiance of the bedroom restful. This is the most personal place of the house, and it's also a place where we usually read, watch TV, write, and so on. Comfort, light, sound, and colors have to be well thought-out and considered.

CLS Architetti Studio: The bedroom is the most important room in the house, so it should be well designed. I personally don't like to have any storage furniture in a bedroom—just a big, contemporary bed and maybe a fireplace.

John Chrestia: The most luxurious element for bedrooms—apart from incredible bedding—is enough space to have a small, separate sitting area for relaxing or reading. I love two club chairs and an ottoman. If there's not enough room for a sofa, consider a small loveseat. You need to have a place to sit—to relax or watch TV or even work—other than the bed. It makes a master bedroom infinitely more comfortable.

Charles Spada: Grown-ups' bedrooms should be quite and harmonious, soft and inviting, an escape from the pace of the day, a private retreat away from the rest of the home. Walls upholstered with a neutral fabric add a richness and warmth no wallpaper or paint treatment can compare to. Children's rooms, on the other hand, should be fun and colorful and incorporate learning elements.

David Ling: I think that incredible bedroom linens should be the main focus. Then, I like to design the bedside table and headboard to match. Lighting should be separately switched, adjustable, and dimmable. When in bed, though, I like to focus on a great view, be it outdoors or indoors.

"Luxury must be comfortable; otherwise, it is not luxury."
—Gabrielle Coco Chanel, fashion designer

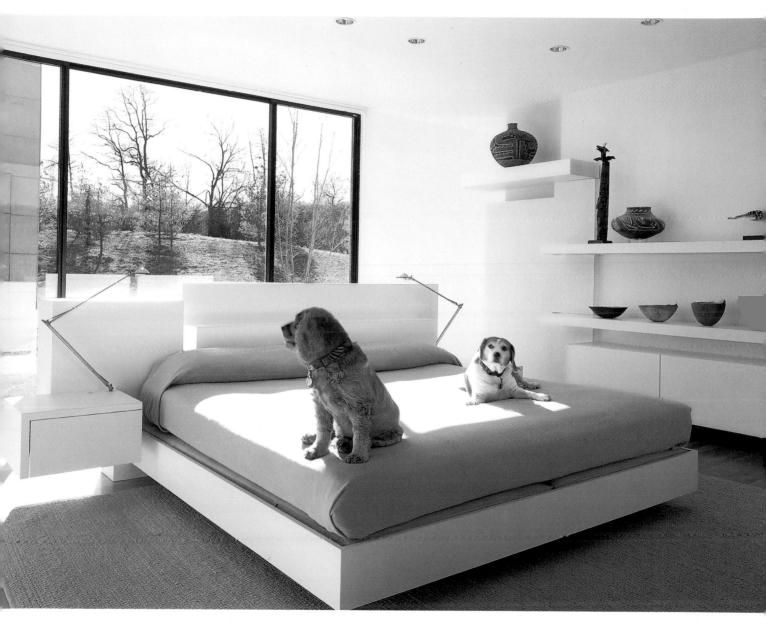

Serenity is written all over the faces of these pups. In a bedroom designed by David Ling, the architecture of the bed and the breathtaking view beyond it are what make the space feel sleek, organized, and serene.

33. Reading lights and bedside tables should do their job.

Kelly Wearstler: Bedside tables must have drawers and storage areas behind doors or drawers—who wants to see clutter? Bedtime should not be distracting, so the mood of the room should cater to your needs. As for lighting, an overhead downlight is great as is a lamp with a three-way switch for different lighting levels.

Heather Faulding: The lighting should be dimmable and part of the architecture, with a switch reachable from the bed. Also, bedside tables should accommodate all your bedside stuff—telephone, reading material, vitamins, newspapers—with built-in compartments.

CLS Architetti Studio: You must have a good reading light, and it should be adjustable for reading, resting, love, and maybe even eating.

Robert Cole/Sophie Prévost: The nightstand is very important to me. It has to have one or a few drawers to store bedtime reading material, glasses, and the magic hand cream. When nightstands are too small to accommodate a lamp comfortably, sconces with adjustable arms are a good solution. Also, we have seen small chandeliers hung above the nightstands. They're a wonderful, unexpected solution.

John Chrestia: In lighting a bedroom, it's important to layer your light sources. You need swinging-arm or standing lamps near the bed and over the seating area to give light for reading or working. I think that some type of overhead light is necessary. I like to use can lights in the ceilings in each corner of the room, because it's relaxing when all four corners of a room are softly illuminated.

Celia Domenech: A bedside light that works independently is essential. It should be a small spotlight that illuminates your book rather than your sleeping partner!

Laurence Llewelyn-Bowen: I love beds placed in the center of the room with a chunky headboard or console table designed to take table lamps. Alternatively, lighting integrated into a wall or headboard allows you to be creative with furniture dressing on either side of the bed. It's nice to be creative on this issue and not feel constrained to have matching cabinets or night tables. An informal pair of chairs loaded with books, magazines, and maybe a bud vase can be a lovely alternative. A bedroom is not a bedroom without piles of books.

Tanya Hudson: Lighting should be on the wall so as not to take up restricted space beside your bed. It is also in the best position for reading. Bedside tables are better if they are a stacking drawer unit. A shelf behind the bed can also be really useful.

Charles Spada: I prefer wall-mounted swinging-arm lights on dimmers. These allow for maximum use of the bedside table surface. Night tables should be generous enough to suit the needs of the homeowner and in scale with the amount of available space. In addition to a good-sized surface, there should be at least a drawer, shelf, or internal compartment for storage.

Thomas Jayne: I like light fixtures with projecting arms that can be adjusted to direct their light right where you want it. It could be attractive clip-on lamps, made of brass or iron—just not those plastic ones—a swinging-arm lamp that attaches to the wall, or standing lamps with adjustable armature.

This ideally proportioned bedside table and standing lamp with adjustable swinging arm perfectly illustrate designer Thomas Jayne's advice. Style meets function and every element is expertly considered.

34.

Choose the most luxurious linens you can afford, then add more personal touches like artwork, flowers, and books.

CLS Architetti Studio: Beds should be made up with the softest, white sheets—linens that feel like they came from your grandmother—no patterns or colors, just worn linen that never has to be ironed.

Celia Domenech: The most important things for a bedroom are natural light followed by natural Egyptian cotton high-thread-count sheets. I like to use simple bedding—plain white or cream for sheets and pillow shams—with added embroidery in details that are extracted from the color and pattern of the room.

Tanya Hudson: In the bedroom you need lots of luxurious textures for cushions and a large bed.

Thomas Jayne: My favorite luxury items for the bedroom are artwork and fine linens. There is no sin in using all-white or off-white linens. Simple white-on-white bedding almost always works. If a client has his or her mind set on a fancy bed with bed hangings, upholstered headboards, and the like, I would start decorating with the bed and the linens.

Laurence Llewelyn-Bowen: Regardless of scheme, most British people stick to crisp, plain-white bed and bath linen. There is an element of understatement to this that many admire, but I often feel it slightly misses the point. Finding a plain or patterned linen to coordinate creates an additional layer of design pleasure.

Axel Verhoustraeten: The only rule for designing a bedroom is lightness and purity of the materials. The fabrics and linens must be in harmony with people who use them, not the other way round. The study of one's personality unveils the choice of these materials.

Kelly Wearstler: I prefer simple linens—crisp, clean, and a light color. I like to add an embroidery detail. Towels also should be white or a variation of white—crisp and clean. Luxurious bedding, pillows, mattress, and a fabulous chandelier make any bedroom feel more private.

Heather Faulding: Cotton sheets with high thread counts and luxury linens are the underwear of a bedroom. Linens can quite easily create the style and contrast in a bedroom and even be seasonal to allow for a change of mood. For a soft touch and personalized feel, add flowers and paintings.

Charles Spada: Look for the highest thread count per square inch when choosing linens. Avoid frilly patterns and textures that are difficult to maintain. Flowers are wonderful in a bedroom on a table or bureau in order to soften and bring nature's beauty into any room.

John Chrestia: Artwork in bedrooms and baths are the ultimate luxury item.

Although small, this serene-feeling bedroom incorporates every aspect of a well thought-out design. By combining luxurious textures in the bed linens with perfectly proportionate side tables, well-placed lighting, and personalized touches of fresh flowers, books, and artwork, designer Charles Spada made this bedroom come alive.

35.

Bathroom design—whether an open wet space or a traditional setup—and materials should be practical, above all.

Axel Verhoustraeten: Water is the origin of life. Let it invade your space.

Robert Cole/Sophie Prévost: In bathrooms, we feel that the materials have to make sense—that is, be appropriate for their purposes. For example, a silk shower curtain, which hides a plastic curtain on the shower side, does not make sense. It needs to be protected and, therefore, is inappropriate. Good design includes selecting appropriate materials that serve and celebrate the uses they are intended for. Glass tiles, limestone, soaking tubs, teak duck boarding, heated flooring, and towel racks, along with thick, white terry bath towels are all practical and evoke luxury.

Heather Faulding: Don't do open showers in bathrooms for children or messy users, unless it's designed so that the water is somewhat contained with showerheads around the corner. We use them a lot and love the idea of making the bathroom bigger but do so with practicality in mind.

Kelly Wearstler: Open showers must be done in a very large bathroom. Actually, I recommend shower doors—who likes steam everywhere?

Celia Domenech: The benefit of a large, open-plan wet area is the clean and sleek visual appeal that it gives your bathroom. The problem is that a wet floor is somewhat unpractical and also undesirable after showering, particularly if you don't have an independent, dry area for the sinks and toilets.

Laurence Llewelyn-Bowen: Wet rooms are a bone. Everything gets wet, thus forbidding the opportunity to include nice decorating objects within the space. Ultimately, they become mere machines for showering, which are fine in public baths or gymnasiums but are a chore in a domestic setting.

John Chrestia: A large, commodious shower that has an extended wet area and lots of windows is the ulti-

mate bathroom luxury. For bathrooms, my favorite element is ample space—a walk-in shower separate from the tub, an enclosed water closet, and a place to sit, such as an upholstered bench or chair. I like baths that have a peaceful and serene quality, with more white than any other color—not a stark white but a soft, creamy marble. I also prefer natural stone to manmade tiles in a bath.

Tanya Hudson: A shower room is great if you have a large space and subfloor heating so that the floor isn't too cold and drains easily. But you need to have the dressing area and other fittings, such as the sink and toilet, far away from the spray zone.

This bathroom, which was designed by Tanya Hudson's firm Amok, is a spacious tribute to the ocean view. Designed with built-in storage and an open shower, edged on one side by a window wall and separated from the sink area by a partial glass wall, the space feels large and luxurious.

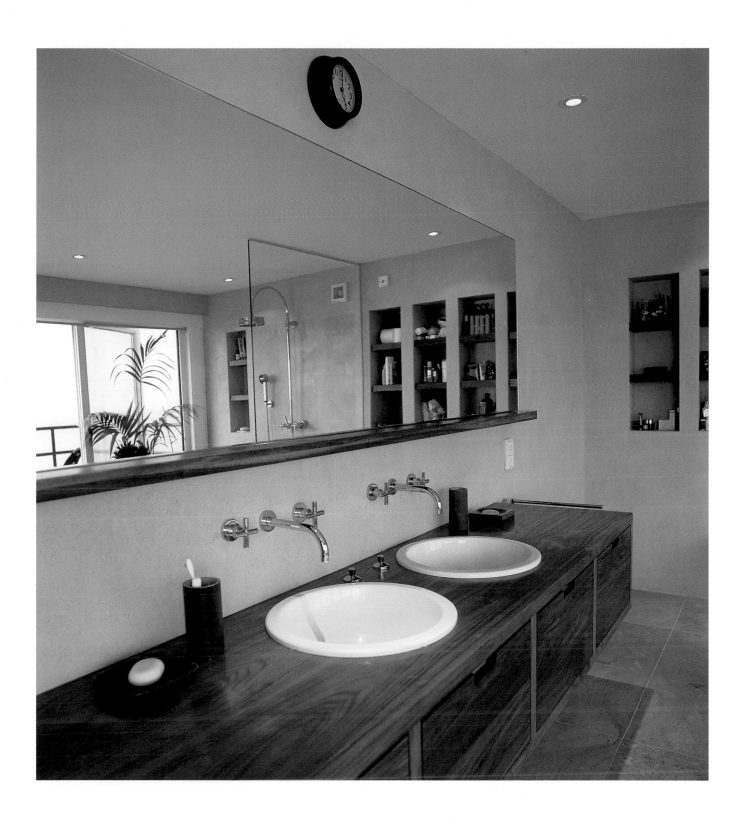

36. Lighting a bathroom can be tricky—be sure to make it flattering.

CLS Architetti Studio: Lighting for a bathroom needs to be specific. An overhead light, in front of a mirror, should be directed at the space between you and the mirror. It should wash the face with light without casting any reflection in the mirror.

John Chrestia: Two sources of light are necessary in every bathroom. You need a combination of lighting from above—a clean, white halogen light in the ceiling—and incandescent sconces.

Robert Cole/Sophie Prévost: Good lighting at vanities is very important. Ideally, there should be three sources: above and on both sides of the mirror. Two sconces on either side also work well—nothing less than that. These should be at least 60 watts, with a white glass shade to provide even lighting. The fixtures can always be put on dimmers for a softer atmosphere.

Thomas Jayne: Sconces on either side of the mirror are the only way to have good lighting on the face. It is wise to have another source of light, too. I like skylights in bathrooms. They enhance the usually small space of bathrooms by focusing the light in a beautiful and dramatic way.

Heather Faulding: Recess the lighting if possible, and always have it at head height and lower to eliminate shadows.

Laurence Llewelyn-Bowen: Mirrors above bathroom basins are useful for reflecting light and space, so keep them large. Illuminate the arrangement with bright wall brackets placed symmetrically on either side of the mirror.

David Ling: Bathroom lighting is important. The light source should be as close to makeup lighting as possible. Lighting from above casts shadows that might make Bela Lugosi happy, but it's probably not the look you're going for. Frontal lighting is the most flattering, which means wall-mounted fixtures in the mirror area.

Kelly Wearstler: Two sconces: one on each side of the mirror. Balanced light is important for a nice look. Overhead downlights will give you raccoon eyes. Also, try a waterproofed step light in the shower for nice ambient light.

Charles Spada: Vertical incandescent lighting flanking a mirror offers almost shadow-free illumination. The mirror should be as generous in proportion as the space allows—full width above a vanity. Decorative, illuminated mirrors are best over a pedestal sink.

In this bathroom, designed by Axel Verhoustraeten, the mirror is set at an angle from the sink, and the light fixture is attached to the wall on the other side. The result is a glare-free reflection that allows you to use the mirror without having to gaze at yourself every time you wash.

37.

For master suites with attached bedrooms and bathrooms, the decor should be seamless.

Heather Faulding: A bed and bath suite should transition well but needn't be identical in color and style because their functions are so vastly different. Bathrooms should contain white, stainless steel, or black fittings so that replacements or additions at a later date are easier. A bedroom offers an open palette. I believe, though, that this is the one room in the house that should be all about calm, so consider soft, cool colors and clean lines.

David Ling: I like to design bedrooms like the most luxurious hotel suite, having the space flow from bedroom to bathroom to walk-in closet without any doors. Then, all you need are skylights, a fabulous view, a concealed TV and media, sculptural headboards, a refrigerator, spa-like facilities with generous sinks, a freestanding tub, a shower room—not a stall—Frette linens changed daily, and a breakfast tray.

Laurence Llewelyn-Bowen: For those lucky enough to have a bathroom ensuite to their bedroom, there is a simple rule: If the bathing area is visible from the bed when the door is open, then the decorative scheme should match the bedroom. The same applies to dressing rooms. If, however, the bathroom is very much a separate area, you can indulge a different scheme or variation on the bedroom theme.

Kelly Wearstler: A bathroom and bedroom in a master suite should be integrated for the most part. You want the design to feel somewhat seamless.

Axel Verhoustraeten: Treat a bedroom like an oasis and a bathroom like a water fountain.

Thomas Jayne: I have seen extensive and expansive dressing and bath suites with his and her baths and dressing areas—sometimes larger than the bedroom itself. Most Americans live with more limited space, so an integrated master bedroom suite is a nice option, if you don't have to share your bathrooms.

Robert Cole/Sophie Prévost: The bedroom and bathroom should flow nicely. Their look and feel should complement each other but not necessarily match. These are different rooms for different purposes.

Charles Spada: A master suite should be unified—designed and decorated as a unit—to incorporate the sleeping and reading areas, the bathroom, and dressing rooms.

Separating the bedroom from the bath in this master suite designed by ColePrévost is a rolling wall of textured glass. It allows for a seamless flow and, at the same time, a bit of privacy. The continuation of materials—sheets of stainless steel, waxed concrete flooring, and warm woods—from the bedroom's sitting area into the bathroom creates the illusion of more space.

38. Closets are out, wardrobes and dressing rooms are in. If a closet is the only option, keep it organized and closed.

David Ling: Flexible storage is essential—both hanging and shelving. Flexibility is important because fashion changes, seasons change, and needs change. Then, after everything is adjusted perfectly, hide it.

Laurence Llewelyn-Bowen: If possible, a separate dressing room is better for your clothes and for you. Squeezing everything in means stress for the outfits and stress for you when trying to find the right piece of clothing. If a separate room is not appropriate, a large, fine antique clothes press with a cedar interior, acres of hanging space, and plenty of drawers is a strong second.

Robert Cole/Sophie Prévost: Study your wardrobe carefully. Measure the linear feet needed for short-hanging items (jackets) and long-hanging items (dresses), as well as shelves for folded items. Don't forget the shoes! Think about space to store out-of-season items.

John Chrestia: My goal is usually to keep my clients from dressing in their bedrooms. Space permitting, I like an entire dressing area with lots of built-ins that can be closed off from the bedroom so that the space is reserved strictly for resting and relaxing.

Thomas Jayne: I try to make closets as flexible as possible. If you are designing for a special client, say, a New York socialite, then you will need a large amount of vertical space to hang ball gowns. In contrast, I, alas, have no ball gowns, so I double-hang my jackets and pants and require less space. It is a great luxury to have a counter space in your closet for your wallet and pocket paraphernalia, allowing you to dress in one place.

Tanya Hudson: A separate dressing room is ideal but not always possible. It's great to be able to see everything exposed so that you don't forget what could be the final touch to your outfit. Sliding doors to a closet are a real pain because you can't fling them open and have a good rummage inside.

Kelly Wearstler: It is best for your entire wardrobe to be in one area. The fewer the rooms involved, the less fashion drama. Shelves, drawers, and plenty of hanging space are key. Bright lighting is also important; remember, dark woods eat up lots of light.

Charles Spada: Closets, because they can be expensive, should be kept simple and be well planned in advance. Drawers of generous width—but not too deep—are neater looking than open shelving and probably easier to keep organized. Estimate the amount of long-hanging and short-hanging space needed and the number of sweaters, shirts, pants, and coats to determine the number of drawers or shelves needed. A small, sturdy bench or stool is also useful, as is a specific place for shoes, belts, handbags, and jewelry.

"It is important for a closet or dressing area to have a good amount of light, which allows you to see the real color of your clothing as well as yourself in a full-length mirror. A little bench or chair next to it also helps," says Celia Domenech, of this bathroom cum dressing area. Here, the designer does this with clean, white open shelving and a flood of natural light.

Chapter Eight: Kitchen Considerations

It may be the heart of the home, but the kitchen is often the place where even the most style-conscious cook takes leave of his or her aesthetic senses. Of course, this doesn't have to be the case. With so many new options for stylish stoves and ergonomic refrigerators, not to mention slick, little sinks and candy-colored microwaves, the design opportunities are endless. In the kitchen, function may overtake form, but with the help of few good habits—like where to arrange the appliances and how to light your cooktop—your highly effective kitchen can also be the height of fashion.

39. Set up major appliances in the form of a triangle for maximum ease and efficiency.

Laurence Llewelyn-Bowen: The kitchen works best when conceived as a triangle in plan. There should be an easy step between sink, fridge, and stove, allowing effortless movement between all three. All other appliances are kept in another area.

Thomas Jayne: A reasonable triangle of steps in the kitchen is ideal—two or three between all major appliances. If you are dealing with an old house, then you make do and appreciate a less-than-ideal layout for its charm.

Tanya Hudson: I like to have a flow designed into a kitchen: preparation, cooking, cleanup. This means that one task doesn't require the same work area as another and also allows for a few people to work in the kitchen at once. Therefore, the fridge, sink, and preparation utensils would be around one area, the stove and cooking utensils around another, and the dishwasher close to the plates—and ideally near the sink as well.

Heather Faulding: The refrigerator is the appliance most used by the whole family. Make it accessible without disrupting the flow. The sink should be in the general range of the refrigerator, and the stove makes up the third part of the triangle.

Celia Domenech: For practical cooking, the best setup is to have sinks and refrigerators close to the stove. I call it the "free triangle." And don't forget to have the garbage close at hand, also.

CLS Architetti Studio: When designing kitchens, we work with a professional chef to decide how to make it a successful work space. Above all, it has to be functional. It's great if it's big with enough room for industrial-quality appliances. I like it when a kitchen feels fresh, with lots of open shelving and plenty of room to store large quantities of food. The ideal is to have a kitchen that opens up to a garden.

Kelly Wearstler: I like a kitchen with an island, and, of course, the island must have a sink, small refrigerator for veggies, and a warming tray. The stove should be near the refrigerator, with counter space in between. The island sink should be on the cooktop side. The main sink should be on the opposite side of the island and sit next to a dishwasher and garbage disposal.

David Ling: I like to arrange the kitchen appliances in order of the actual use. For my own cooking habits, I prefer the refrigerator next to the sink and the sink next to the stove. The remaining appliances that aren't used as often should be hidden until needed.

"Taking the cream out of every glass of milk—that's the way I understand decorating."
—Dolly Hoffman, interior designer

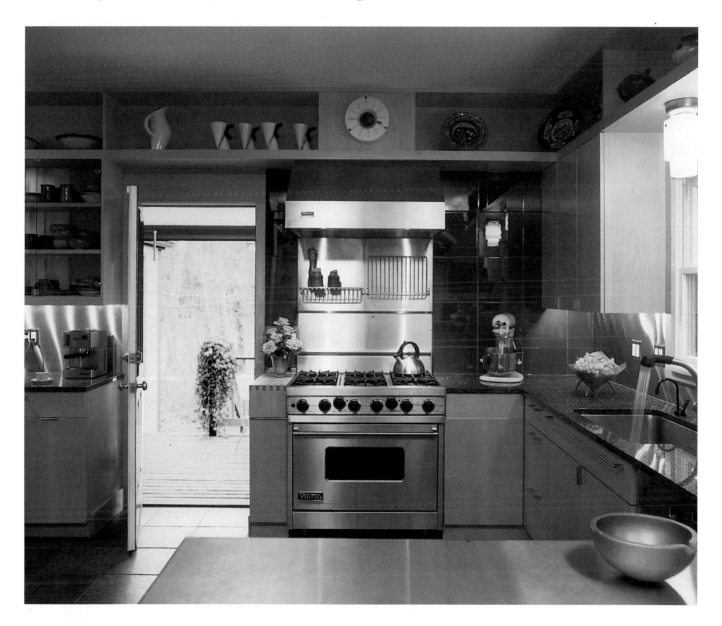

The golden triangle rules this kitchen created by ColePrévost. With the refrigerator only steps away (to the left of the photo), the stove and sink make up the rest of the shape. This kitchen incorporates the ideals in this chapter: specific lighting, warm and innovative materials, organized storage, and a garden just steps outside.

40. Add some extra counter space.

David Ling: I find generous counters impressive. A long swath of uniform surface with small-scale detail or graining—be it granite or cement—is great for a kitchen.

Heather Faulding: Always have room to set things down, preferably on both sides of the refrigerator. All phases of food preparation need space around them, both before and after. I personally loathe kitchens where there is a vast floor area across which you're leaping from appliance to appliance. Why not opt for the extra counter space of an island, however skinny it has to be?

Celia Domenech: To add some interest and versatility to kitchen counters, you can play with hidden and moveable pieces. A pullout shelf offers a great extra surface that simply tucks away when you don't need it.

Tanya Hudson: A really deep counter with loads of power outlets means you can have all your great-looking gadgets out along the wall and plugged in ready to use and a good work surface in front.

Charles Spada: Sinks should have their own counter space, as should the stove and fridge. Work islands are often poorly designed, with the space not used to the best advantage. The storage should be configured into practical sections. You should have full-height cabinets at either end, flanking two rows of drawers down the center on one side of the island. One end cabinet can have pullout shelves to hold small appliances; at the opposite end, a pullout waste basket or recycle bin. The center two rows of drawers should hold spices, vitamins, cutlery, cooking utensils, freezer bags, dish towels, and all necessary work tools.

Thomas Jayne: The best way to create more space is to have fewer things cluttering your counters.

CLS Architetti Studio: It's nice to have a movable section with a marble or butcher-block top so that your kitchen is adjustable.

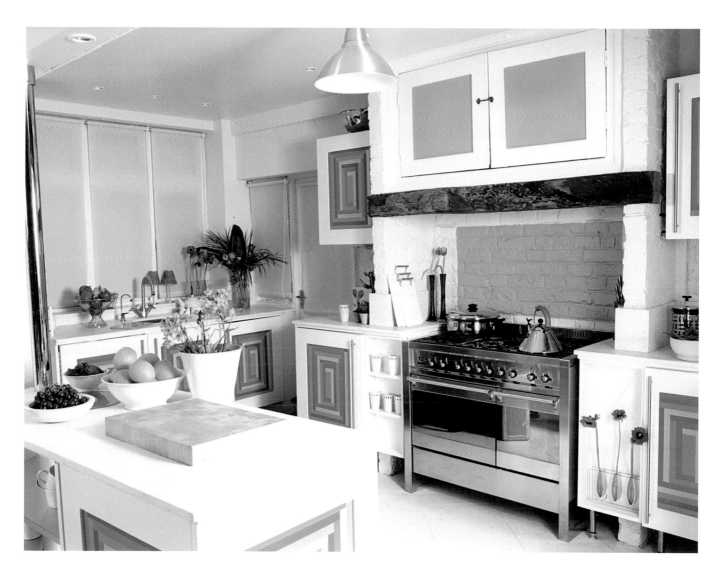

In this pretty-in-pink kitchen renovation, Laurence Llewelyn-Bowen was faced with the dilemma of an old-fashioned kitchen that offered big, sturdy appliances but little counter space. The addition of a center island with open shelving along the sides practically doubled the original amount of counter space.

41.

Whether natural and renewable or innovative and industrial, materials are the key to an interesting kitchen.

John Chrestia: I like the use of stone and tile in kitchens—marble rather than granite. It's so much more elegant. Like a European bistro table, it develops a beautiful patina as it gets worn. I also like to use stainless steel with limestone, which can be sealed so that it's nearly indestructible, or stainless steel with concrete that's been pigmented so you have silver mixed with vibrant color. Concrete is great on floors or counters because it goes so well with kitchen materials, like wood, stone, and steel.

Thomas Jayne: The materials that are easiest to clean—plastic laminates and stainless steel—are not as beautiful as stone. I like soft wooden counters in areas where dishes and glasses are stored. It saves on breakage on hard counters.

Robert Cole/Sophie Prévost: Black granite looks terrific but needs constant cleaning because it shows everything. Speckled materials are more forgiving for the less obsessive cleaners. In general, we prefer natural materials. Limestone is a favorite, but be forewarned: Some of the hardest ones, honed and sealed, can still be sensitive to oils or the acidity of lemon juice, which attacks the sheen of the finish. Concrete has a lot of custom possibilities. It can be colored. Decorations can be embedded into its surface. There are also some terrific resins and laboratory countertop materials available, but these are not always less expensive.

Celia Domenech: My favorite materials for countertops are hard, easy-to-clean surfaces like granite, hardwood, and stainless steel.

Heather Faulding: There are lots of man-made stones available in slabs for a change in color from the standard granites. Be careful of wooden counters—they can be breeding grounds for bacteria—and tile counters, which have uneven surfaces. Corian is great because it is softer than stone and allows sinks to be made integral with the counters.

Charles Spada: Stone is the best counter surface. It's easy to clean when properly maintained—just use glass cleaner and a clean cloth or paper towel for efficient cleanup.

Kelly Wearstler: I love to use marble, limestone, or stainless steel on countertops. Stainless steel is the easiest to keep clean.

Laurence Llewelyn-Bowen: Inevitably, practicality prescribes durable work surfaces. I personally like a variety of different finishes that highlight separate storage or appliance units to create an informal feel.

CLS Architetti Studio: The more real and true the materials, the better; I like stone, stainless steel, and concrete.

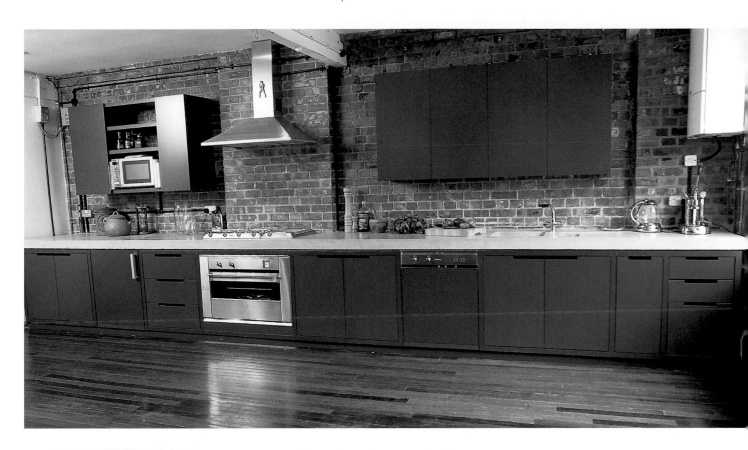

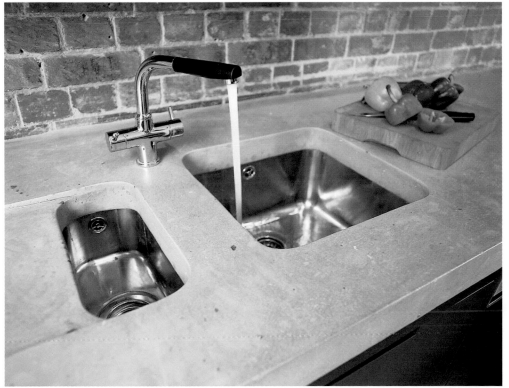

Combining both natural and industrial materials, designer Tanya Hudson created a kitchen that already has a delicious mix of flavors— "Granite and marble make stunning and practical work surfaces. We fabricated a 16.5-foot- (5-meter-) long and 4-inch- (10-cm-) thick concrete worktop in a loft apartment. It was stunning and practical. Wood is beautiful but requires a lot of maintenance," says the designer.

42.

Kitchen cabinetry should look neat, tidy, and interesting.

John Chrestia: In doing kitchens, I try to avoid a sea of cabinetry. You don't need to use those standard fitted upper and lower cabinets. As an alternative, I like to stack cabinets in towers at the end of a long counter. It's the same amount of storage, and it frees up the walls for shelving. Shelves in a kitchen—whether they're steel, glass, or wood—are nice because they negate that "showroom kitchen brochure" feeling.

Kelly Wearstler: I am a firm believer in closed storage—fitted or unfitted works, as long as clutter is hidden.

Robert Cole/Sophie Prévost: For easy storage, unframed glass doors are a nice compromise between open shelving and cabinets. For a clean, minimalist look, consider using frosted glass; it frees you from being neurotically neat while still providing translucency and glow. Deep drawers are wonderful for pots and pans.

Heather Faulding: Neat cooks can afford to use open shelving or glass-fronted cabinets. Generally, it's more practical to have your frequently used food and condiments on shelves along with cooking implements. Dishes can be stored in glass-fronted cabinets with brightly colored interiors. And all the rest, which is harder to organize, should go behind closed doors or in an appliance garage with a roll-down front.

Axel Verhoustraeten: Closed cabinetry is better than open, for the sake of hygiene.

Laurence Llewelyn-Bowen: Many people have little choice but to have fitted galley-style kitchens. Poor them. Kitchens work best when they are treated like another room with storage conceived as furniture. A good ratio of practical closed storage and decorative open storage should be sought.

Tanya Hudson: A wall of closed cupboards looks clinical and isn't easily accessible, but having them all open will inevitably be a mess—this is a functional room, not a showpiece.

Charles Spada: Overhead cabinetry and shelving collects dust and grime, as does everything displayed on it. In lieu of overheads or shelves, incorporate full-height units that serve as a pantry, with pullout shelving and interior drawers. We design these pantry units as part of the kitchen cabinetry, often housing the wall oven and microwave, as well as storage.

Celia Domenech: I like to mix cabinets and shelving to create a visual rhythm. Open storage is very handy, but it cannot be messy. I keep the cans and some other ingredients in a closed cabinet with only china, bowls, and cookbooks exposed.

Although closed cabinetry may be cleaner looking than open shelving, this kitchen, fitted with open shelves and plenty of stainless-steel cookware and designed by Axel Verhoustraeten, feels professional and ready to go. With utensils at your fingertips and pots behind quick-close cabinets, you won't waste any time in this kitchen.

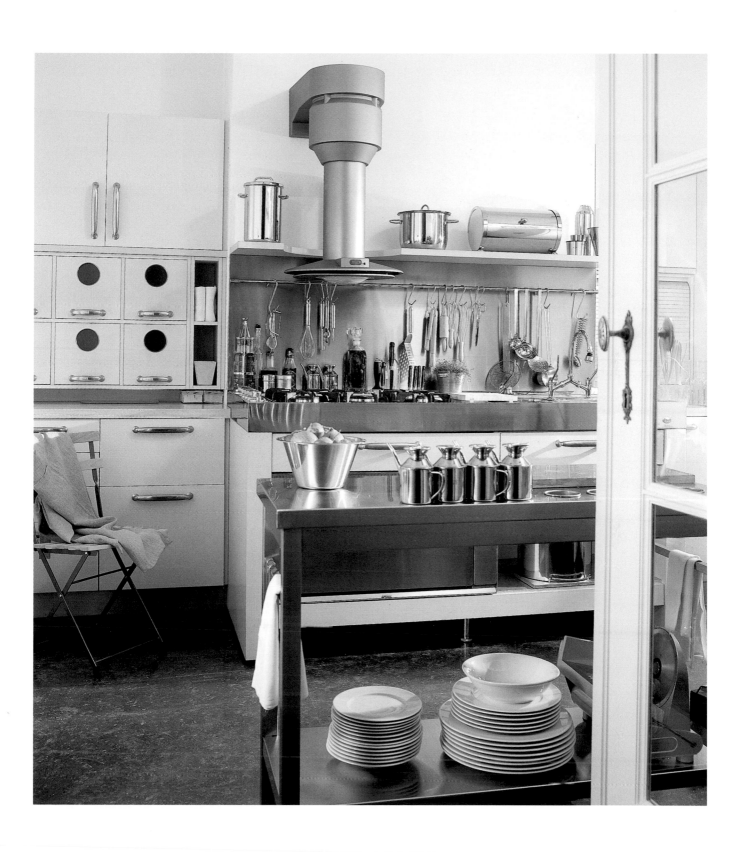

43.

Kitchen lighting should be abundant and task oriented.

Kelly Wearstler: Task lighting is great on counters and under cabinets. A fabulous chandelier is also great as a giant decorative element and good source of light.

Thomas Jayne: You need to have many moods available in a kitchen that is viewable from your dining or living spaces. I often overlight the kitchen and then use dimmers to create different moods—from candlelight dinners to what I call "game show" lighting when you need a bright space.

John Chrestia: Obviously, it's important to have a well-lit work area. Whether it's recessed overhead can lights or under-cabinet spotlights, the light should shine directly onto the work surface. Apart from that, lots of incandescent sconces work well in a kitchen to provide warm light for the heart of the home. If you have an island or a table in the kitchen, you should incorporate a stylish hanging fixture. It doesn't matter whether it's a beautiful, old, crusty iron chandelier or a more contemporary pendant light.

CLS Architetti Studio: You need to have lighting that keeps the colors real. You can't have lights that alter the color of food. I suggest going with halogen and keeping it bright where you are preparing food.

Tanya Hudson: Design the lights to suit the layout. Under-cabinet lights are helpful for working and create a nice, intimate level of light when the general lighting is not on.

Celia Domenech: In addition to the natural light, I use two types of artificial light. For the cooking part of the kitchen, the light has to be homogeneous and free from shadows in a fairly high level. Low-voltage halogen downlights are a good option. The second is the decorative light that provides an attractive and warm atmosphere to the eating area and to other accents.

Robert Cole/Sophie Prévost: A nice pendant can refocus the center of attention away from a messy action area to an eating space. We have found that providing bright lights for cleaning up is helpful.

Laurence Llewelyn-Bowen: Kitchen lighting needs to be bright and cheerful with clean, low-voltage halogens illuminating what you are doing. Ensure that the spotlights are not behind you so that you don't cast a shadow on your chopping. For kitchens with space to sit in, I love to sprinkle a judicious handful of table lamps on work surfaces to create a more relaxed alternative lighting scheme.

Charles Spada: Good kitchen lighting is easy to achieve: use under-cabinet lighting to light the work surfaces, recessed ceiling lighting and wall washers to illuminate traffic areas and upper cabinetry, pendant lighting above a work island, and ceiling-mounted pendant lighting above the dining table.

A combination of natural light, overhead halogen spotlights, and a large hanging fixture over the table makes this kitchen feel warm, bright, and welcoming. By carefully lighting the work space and then giving the eating area an atmospheric pendant lamp, designer Axel Verhoustraeten made the space more versatile.

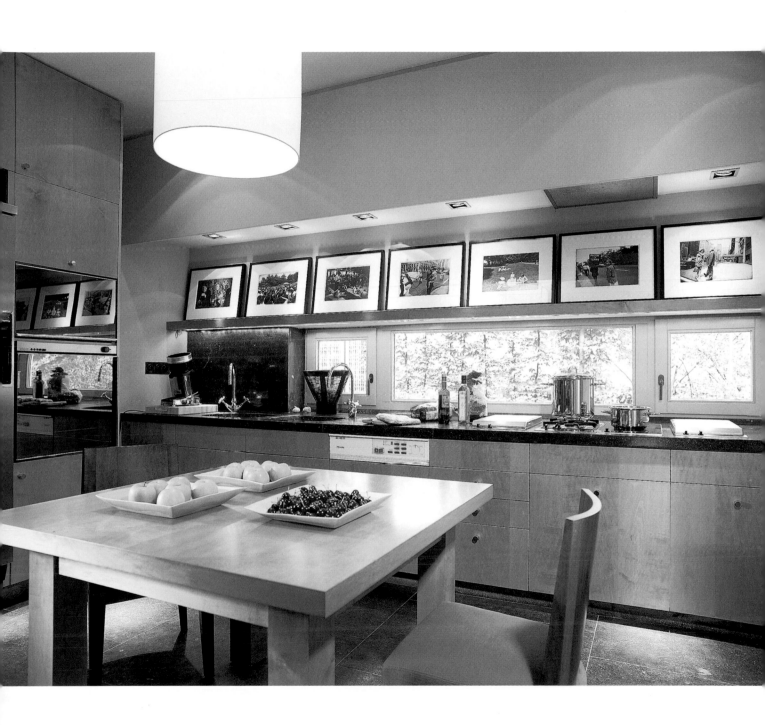

Chapter Nine: Dos & Don'ts for Dining Rooms

Dining rooms are often overlooked these days as we continue to eat out more frequently and throw cocktail hours more often than dinner parties. Few families still eat together in this age of overworked parents and overscheduled children. But the fact remains that nothing can beat an elegant dining room and a delicious meal. The key elements also remain the same—chandeliers, candlelight, slip-covered dining chairs, and silver patterns—but the application is entirely modern. Mixing and matching old with new—for both materials and styles—will bring your dining room into the twenty-first century.

44. Dining rooms need not be stuffy and traditional; they should be as flexible as possible.

Thomas Jayne: Dining areas need to be flexible enough so they are also comfortable. Storage and furniture should be attractive but not workaday. Pullout trays or baskets stored in a serving cabinet can be handy. Avoid little plastic-wheeled carts that go from room to room! A modern dining table can easily be a worktable, which is not always the case with an antique.

Tanya Hudson: Don't enclose the dining area in a separate room; it should be an extension of the living or cooking area—in view of the kitchen is good so that the cook can be sociable with the guests.

Celia Domenech: For a dining table that has multiple uses, the surface has to be durable and, ideally, large enough to accommodate both eating and working once in a while.

Charles Spada: To turn a formal dining room into an informal one, use sturdy, simple furniture. Consider clean, practical style elements such as bare wood or stone floors with an area carpet, if necessary. Items for play or work projects can be easily stored and accessed in a server, armoire, or cupboard.

Heather Faulding: Dining rooms should always be close to kitchen. If you are short on space, set up a dining area in a roomy hallway or transition space. Modern-day eating and entertaining is nothing like the old-fashioned concept of "dining." Comfortable chairs and adjustable lighting are the key to a versatile dining room.

David Ling: Open the space up to the rest of the house, especially the kitchen. Modern light fixtures, modern furniture, modern materials for the floor, walls, and ceiling make for a versatile dining area without sacrificing style and design.

Laurence Llewelyn-Bowen: The dining room is often the most traditional room in the home. This is fine, but pick your tradition with circumspection. Traditional should not mean boring! Because the room receives relatively infrequent and often formal use, you can truly indulge beyond the constraints of day-to-day practicality—so do. It is an area for the enjoyment of fine food and finer wine, so it could be conceived as an elegant—possibly even theatrical—backdrop to the convivial activities taking place there.

Kelly Wearstler: Don't pigeonhole yourself into purchasing a dining room set. Mix and match. Anything goes. Create tension with the chairs and table—a modern table and traditional chairs, or vice versa.

"Ambiance is an unstudied grace...the grace of human dignity."
—William Pahlmann, interior designer

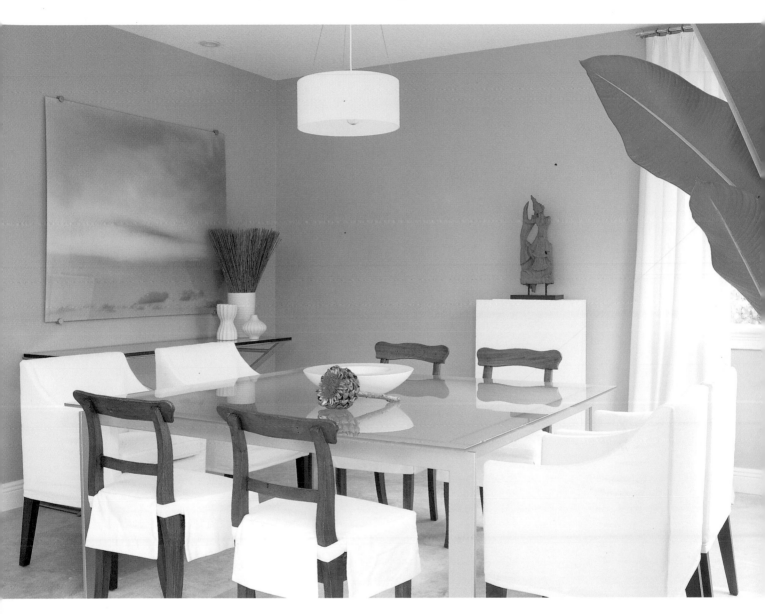

Celia Domenech designed this Florida dining room to make the most of its small, square area. Using lots of white, the designer paired contemporary armchairs with more traditional slip-covered dining chairs around a modern glass-topped table. The result is a clean, neutral palette that allows for both formal nighttime dinners and elegant everyday dining.

45. Dining tables should be big and durable.

Thomas Jayne: Choosing a dining table is more about the proportion of the room than a particular shape. However, rectangular tables are the most flexible—for example, they are good for dinner for two—whereas round tables are good for conviviality, but you'll need a group to fill the table.

Tanya Hudson: Round tables are sociable and flexible in terms of numbers, but rectangular tables work well with most rooms.

Laurence Llewelyn-Bowen: Tables to dine on should be flexible enough to accommodate a variety of seating plans and guest lists. The more democratically minded should consider round or oval tables, which blur the boundaries between host, hostess, principal guests, and those less illustrious. If you have a rectangular table, try seating yourself and your partner in the middle of the table opposite each other in the French manner, which allows you the opportunity to converse rather than being isolated at opposite ends.

Kelly Wearstler: Choosing a dining table shape depends on the shape of your space; round and square are good in a square room, whereas oval and rectangular are good in rectangular rooms.

Charles Spada: I like a generous, expandable, round dining table. When opened into a great, big oval, it's good for extra seating at the head of the table. Tables with a stone or synthetic top are best, because they can be used as a formal or informal dining surface as well as a play or work surface.

David Ling: A circular or square table allows for the most social and equal dining experience, but as your guest list expands, you can add leaves for a more formal oval or rectangular table.

Robert Cole/Sophie Prévost: Get a great table. A big, long surface with a good solid chair is the ideal place to eat, work, write letters, read, sit, or dream. The surface should be one that can withstand daily use. We like the patina of wood that has been worn and waxed over time and prefer big, long rectangles over round tables, which allow you to talk to the person seated opposite you. You don't have to seat lots of people around a long table; you can group them in the middle or along an end. The rest of the table then becomes an easily accessible serving space.

CLS Architetti Studio: The bigger the dining table, the better. I like to be able to fit a lot of friends around the table with extra chairs stacked somewhere out of sight, in case more guests arrive.

This clever dining room was designed by Axel Verhoustraeten. By treating a table for 10 to 12 like it was a small square— only setting the four places in the center—both ends become either serving space or display area.

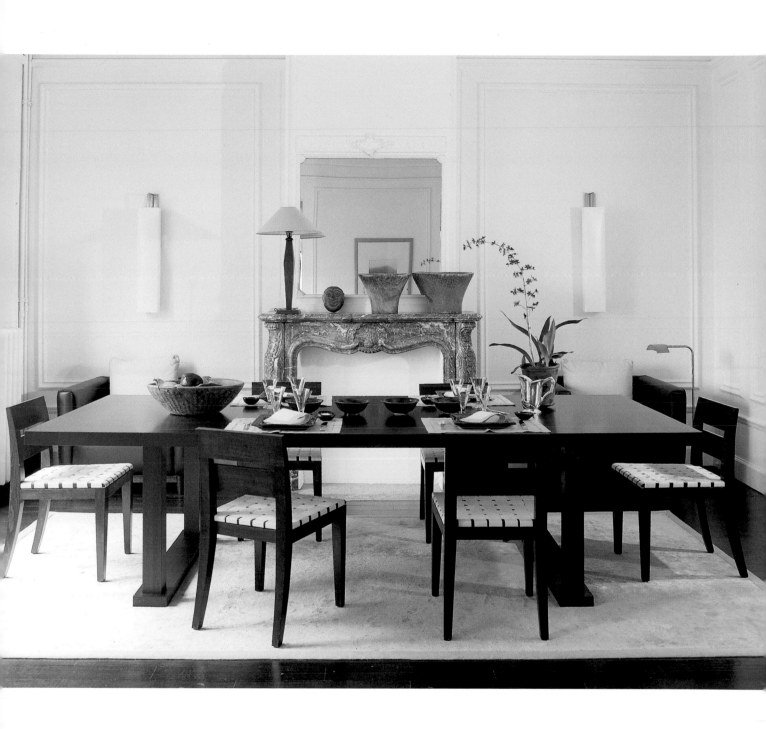

46. Comfort is essential, both in dining chairs and dining atmosphere.

Laurence Llewelyn-Bowen: Comfortable dining chairs can be a valuable resource. Have them upholstered in such a fabric that might mean they are not out of place in a hallway when not in use.

John Chrestia: Above all, dining chairs need to be comfortable. No one wants to sit in "the rack" for two and half hours at a dinner party. If you are using antique chairs, make sure they are comfortable. Also, dining chairs need not be a perfect set. I'm not crazy about the idea of mixed chairs all around the table, but using a variation for the host and hostess chairs works well. Apart from a table and chairs, I think it's nice to have some serving pieces as well, like a buffet or sideboard. It doesn't have to be formal. A server could be a chunk of wood, but laid with food, flowers, plates, and candles, it feels special.

Charles Spada: Every dining room should have comfortable, wide seating with good back support in leather or vinyl upholstery for easy maintenance.

Robert Cole/Sophie Prévost: Make sure the chairs are comfortable. Start there, and find a table based on that. To make seating more comfortable, lower the table height. Most formal tables are too high, making it hard to relax and feel comfortable.

Axel Verhoustraeten: One cannot hear the conversation at a table that seats more than eight people. Banquet-style tables are ridiculous.

Thomas Jayne: A table and chairs with character and comfort are essential.

Armchairs are usually more comfortable than side chairs. If space allows, armchairs all around the table are a guest's dream. Here, comfortable cushions line the seat of dining chairs in a small and cozy dining nook—made cozier by Axel Verhoustraeten through the addition of an antique Asian sideboard and tribal art pieces.

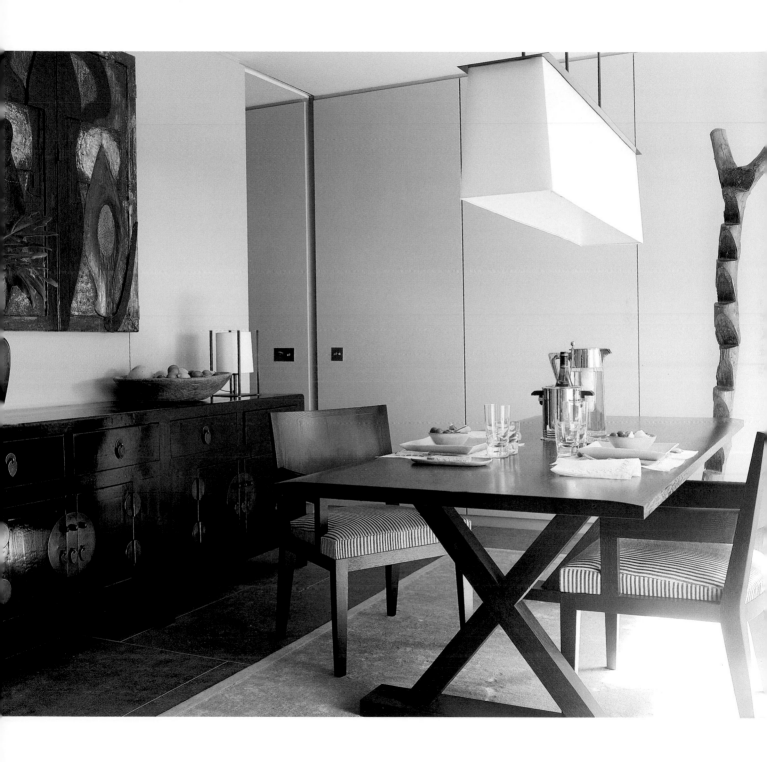

47.

Put all dining room lighting—even your crystal chandeliers—on dimmers.

Charles Spada: The best lighting for dining is a good overhead, unobtrusive light and wall sconces—all on dimmers. And, of course, candlelight for when you need it.

CLS Architetti Studio: We recently designed interesting lighting for a dining room—the table itself is a light. It's the same principle as a photographer's light box, and it's dimmable so that you can adjust the amount of glow on the surface of the table. It's incredible because you can create all different effects with it. And in the end, the plates are backlit, so the food becomes the triumph!

Thomas Jayne: Chandeliers can highlight the height of a room. Candles are mandatory in any dining room.

John Chrestia: I really like chandeliers in dining rooms, but they are not always appropriate. Recessed halogen lighting shining down—and, of course, dimmed—is another option. Candlelight is always wonderful, both in traditional and contemporary settings.

Robert Cole/Sophie Prévost: Lighting the table and dimming the surroundings provides an intimate atmosphere. Candles are a wonderful source of light. They require a certain ritual and flatter you, the food, and your guests.

Kelly Wearstler: Lighting is the key to a memorable table. Do have a chandelier, and put it on a dimmer. Lighting is just as important as the food in a dining experience.

Heather Faulding: A chandelier or some type of adjustable and sensitive lighting is the most important element of a dining room, followed by candles.

Over the center of this dining space designed by John Chrestia, a recessed light acts as an unobtrusive overhead, while candles light a server nearby. Deco-inspired sconces take the place of a crystal chandelier in this space-saving dining area, and an adjacent task light lends a hand from the living room.

48.

Add interest to an otherwise stuffy dining room with tabletop accessories and artwork.

David Ling: The must-haves for a dining room: an enclosure, intimacy, a chandelier, candlesticks, glassware, flatware, a tabletop, linens, and a well dressed butler.

CLS Architetti Studio: All white, very thin bone china—almost translucent—with silver flatware is the most beautiful table setting to me. No tablecloths and no candles. I like natural elements, like leaves and petals, instead of a centerpiece.

Tanya Hudson: Indulgent curtains, candelabras, and dramatic lighting can transform a functional eating area into an intimate space when necessary.

Celia Domenech: Two important elements in a dining room—apart from circulation, light, proportion, and comfort—are the chandelier and the centerpiece. Something fabulous in the middle of the room can make a dining table.

Charles Spada: Traditional dining rooms can be spiced up with color, fabric, art, bookcases, an unusual or incongruous piece of furniture, an oddball chandelier or wall lights, or an enormous mirror.

Robert Cole/Sophie Prévost: A whimsical chandelier in a formal dining room adds a touch of lightness. Linens are a great way to dress up a table. We once saw tables set with two layers of cloth: a translucent fabric atop a colored solid fabric. It was a great way to add color and glamour without being too serious. But whatever you do, don't overload the visuals. The food and the company are supposed to be the focal point of the event.

Heather Faulding: Add drama with interesting lighting, table centerpieces, and artwork. Many dining rooms don't have windows, but it doesn't have to be a drawback—this allows lots of wall space for great art.

Thomas Jayne: When you consider a traditional, formal dining room, you think of all the classic elements: candlesticks, gleaming silver, an ornate china pattern, and a crystal chandelier. However, being a good host is more important than all your things exactly matching. I prefer things with history and interest that play against one another to a strictly proper, matched place setting.

John Chrestia: The best way to add interest to a dining room that feels too traditional and stuffy is a simple, modern mirror or contemporary artwork. You can also use contemporary fabrics in a traditional setting to add some instant interest. Don't decorate your dining room based on your china pattern. I get clients that want to start with that all the time. It doesn't have to match exactly. It's often more interesting to be a little out of step—it adds texture.

"Above all, dining rooms should be a setting for art," says Thomas Jayne. Complementary colors, tiers of fruit, artwork, and some unexpected foliage make Thomas Jayne's dining room feel anything but staid. Blending old and cherished things with bold, new color combinations and wild patterns is often the fastest and most successful way to increase the style quotient in a room.

Chapter Ten: Home Office Checklist

It does seem quite strange that suddenly every home has some type of integrated office setup. Although rarely is it a strictly "thinking-room" as Thoreau suggested, it may be the base camp for our work, our imaginations, our curiosities, and our thoughts. Whether you need a secretary-type desk in a hallway for paying bills and writing letters or an all-out office with D.S.L. lines and big computer monitors for working at home, your office should fit into your home. It should be just as lovely and inviting as other rooms, but it should also be a healthy and productive atmosphere.

49. Make sure it looks more like a home than an office.

Laurence Llewelyn-Bowen: Working from home should be a phenomenal pleasure, affording you the luxury of working in an environment under your control, surrounded by your lovely things. I think it's a mistake to try and convince yourself you're in a conventional professional environment—who wants to work under strip lighting with gray carpet tiles, anyway? Never consider allowing ugly, pedestrian office furniture into your home. An accommodating antique desk or writing table and a comfortable armed chair are all you need. They also draw the eye away from the unfortunately intrusive nature of computers, printers, and fax machines. Your personal style should continue into the work area. Treat yourself to little details, such as a fresh bouquet of flowers next to your computer as a reward for having the independence of spirit to work from home rather than following the herd into the office every morning.

Thomas Jayne: A home office must be treated like a proper room, not an afterthought. Only then can it be comfortable. Many who work from home discount their need for space and end up sitting cross-legged on the floor.

Celia Domenech: A home office doesn't have to look dull. I've seen plenty of different styles, shapes, and finishes for chairs and desks that are attractive. Because of the modern lifestyle, designers have created beautiful lines of furniture that are perfect for the now-common home office.

Axel Verhoustraeten: The creation of a home office space is becoming increasingly important. New technologies are bringing about important changes in this area, and it is still too soon to tell what specific look a home office should have. So far, the most successful designs include a flat-screen monitor incorporated in the wall and a table with an ergonomic chair.

John Chrestia: By nature, your home office should have lots of light, fabric, and texture. It shouldn't feel anything like an actual office. It should be softer and fit with your home's atmosphere.

This desk has been easily integrated into the rest of the loft, designed by Axel Verhoustraeten, so that it can be used for work, correspondence, and a place to talk on the phone. Because it is in keeping with the design and style of the rest of the home, it doesn't stand out or feel business-like. It is simply a work station.

"Perchance the time will come when every house will have not only its sleeping-rooms, and dining-room, and talking-room or parlor, but its thinking-room also, and the architects will put it into their plans." —Henry David Thoreau, naturalist

50. Find the perfect location.

Robert Cole/Sophie Prévost: In a home, it is important to be able to keep the work out of sight when you're done working. If closing a door is not an option, allocate an area with enough storage to be able to put things away. If you can't dedicate an area for home-office work or family bills, consider areas that can double up. Kitchens are becoming more and more common, as are guest bedroom cum home offices, and even bedrooms. Well, probably, the bedroom should be taboo. The idea of sleeping with your work happens all too often and is not very enticing.

David Ling: If you are looking for a room to play double duty as an office, I suggest a guest bedroom, followed by a desk or cubby in the kitchen or bedroom. I prefer the kitchen so it doesn't disturb sleeping. But, if you're an insomniac like me, having it near the bedroom helps the commute.

Thomas Jayne: The dining room can do double duty as a home office. Then next choice could be the kitchen. It is bad to work all day in your bedroom. You need to be especially well organized to work from home. Otherwise, the clutter is always with you, and the feeling of working all the time is present.

Tanya Hudson: The main problem is that offices are always cluttered. Unless you want to spend hours tidying every day, it's best that your office be situated in the room that's used the least. I think some sort of separation between work and home is important. A flight of stairs or separate access is ideal, but obviously this is not always possible. Working from home is great—it is a comfortable environment to work in—but it sometimes blurs the distinction between work and play.

Celia Domenech: Find a space to be your permanent office, which means that you won't need to move your laptop and papers around. I would keep work out of the bedroom—which should be a restful environment—and kitchen—where it could get dirty. The best areas to have an office at home would be in the living or dining room.

Kelly Wearstler: All you really need is a desk with storage and a great comfy chair—if you're comfortable, you'll get more done. If you have to double up a room, a kitchen or dining area are good options.

Charles Spada: If you have a closet, say, full of things you haven't used in a few years and probably never will use again, sell, toss, or donate everything. Then carve out a work area from the closet space. Remove the door, and if budget (and the landlord) allows, open the closet up full width and height, add a work surface, electrical outlets, phone, and D.S.L. jacks, and shelves above with an under-mount light fixture attached. Voila! You're in business.

Laurence Llewelyn-Bowen: If space is at a premium, then slide your office area into the room you use the least. This will mean that there is a feeling of segregation between work and relaxation time.

Celia Domenech found space in a comfy den to create a home office from part of a built-in storage unit. It's organized, well lit with lots of windows, and well designed with a color scheme and rolling office chair that goes exactly with the decor of the rest of the room. It doesn't take away from the function of the den, and the sitting area doesn't interfere with the office part.

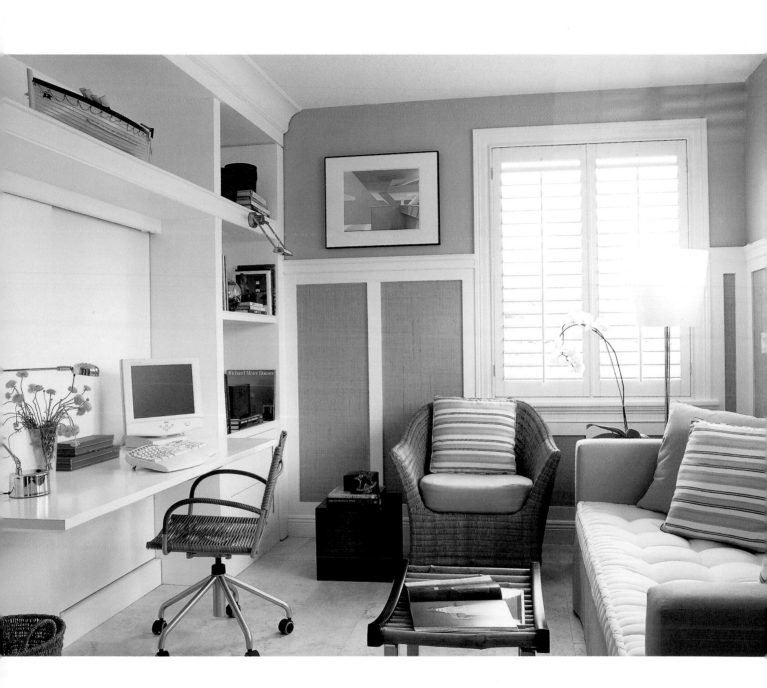

51. Cleverly disguise your work area with fine or smart furnishings.

Heather Faulding: Your desk can fold out or roll out from a closet or even the paneling. A built-in unit, wherever possible, is ideal, unless you have a great antique piece that works. A laptop on an old piece can be great, with lots of storage built in behind it!

CLS Architetti Studio: My own work and living space is my dining table. It's actually a Ping-Pong table, and my grandmother had it made as her own dining table. It's huge, and you can close it and set it against the wall. But when it's open, it's like an island in my home. It serves as both office and dining table, and it's so huge that one side can be my office and one side my dining table.

Tanya Hudson: There are plenty of sexy computers and office furniture around these days. Printers and such can all be stored in cupboards with a roll-down top or slideout base to make them accessible when required and hidden when not. Also, laptops can be tucked away so that the room doesn't look like "PC world."

Charles Spada: You can get wooden hospital bedside rolling tables—great for eating and working in comfort, and an interesting piece of furniture to boot.

Robert Cole/Sophie Prévost: A beautiful desk or table can be used as a computer desk by adding an adjustable keyboard tray under the desk. Also, there is an interesting piece of furniture on the market: When closed, it is a handsome, small wall unit. When opened, it reveals a desk surface, a desk chair, and file drawers and shelves. It is amazingly small for all it contains.

Thomas Jayne: If you use a laptop computer, get a beautiful desk and chair, and then simply store it inside. If you have to have all the accessories—printers, scanners, oversized screen—sometimes it is just a matter of hiding wires and having holes drilled to snake them through—at least when the item is not a precious antique.

John Chrestia: Your work space must be conveniently disguised, whether it's an entire unit that you can close the door on and leave in the corner or a separate table that doesn't have to serve as your dining table. Who wants to be clearing off your entire desk when it's time to eat?

Celia Domenech: If you work in a living room, you could build a wall unit that has space for an office and also for the audio and video components. Your desk, for example, could be one of the doors of the unit that flips down when needed but also hides all the items that a normal desk contains when it's closed.

In this living room, ColePrévost extended a slab of concrete along the corner wall to provide a multifunctional storage and work space. With a laptop and the overhead pendant light on, this setup can quickly convert to work mode. But when it's not in use, it is hidden—its architecture blends horizontally into the rest of the room, and it serves as a kind of second mantle for displaying art and objects.

52. Natural light, good posture, and handsome storage are key elements to a successful home office.

Heather Faulding: A home office space can be as small as a foldaway desktop or it can take up a whole room. Either way, make the technology immediately accessible. There should be adequate storage to keep the space uncluttered. Check ergonomics for desk and seat heights, especially when working from home for long periods.

Thomas Jayne: If you have your bookcase custom built, you could do a false bookcase that opens up for secret storage behind it. If detailed properly, it is inconspicuous. The idea even works for false wall sections—you could tuck a door pull under a chair rail, and no one knows it is there but you.

Laurence Llewelyn-Bowen: Work storage for the home should be, wherever possible, of the closed-door variety. If open shelves are necessary, for whatever reason, consider covering ugly file boxes with wallpaper so that they fit easily with the rest of the scheme.

Kelly Wearstler: Purchase an interesting vintage dining room cabinet with doors for hiding books and storage. Standard bookshelves always look inexpensive and show clutter.

Charles Spada: Build a step-backed bookcase—10-inch to 12-inch (25.5 cm to 30.5 cm) deep shelves and 14-inch to 16-inch (35.5 cm to 40.5 cm) deep base. These are ideal when the lower drawer section is used as a file cabinet and storage for paper supplies and the upper section displays books.

Celia Domenech: It's best if your desk can be close to a window and have a natural light. Selecting a chair for good posture is also essential. Storage to organize and file my papers would be my last home-office desire. For light-looking bookshelves, you can create free-standing shelves that can be placed anywhere in the house. Another idea would be to install one shelf covering the full extension of a wall in between the window and the ceiling with a rolling ladder in a corner.

Tanya Hudson: For storage, I prefer bookshelves that are really chunky wood, floor to ceiling. Whatever is being stored in them, they look like a substantial feature in the room and a part of the structure.

Robert Cole/Sophie Prévost: There is never enough storage, nor are there enough clever ideas to deal with this problem. Turning a wall into a bookcase is sometimes a great solution. It dresses a room nicely and can be designed to accommodate niches and open spaces for artwork.

This home office seems to be born out of an incredible wall of built-in storage for an impressive antique book collection. The result is a shapely desk designed by Charles Spada that feels unobtrusive and elegant—with a bouquet of flowers and a Louis XV chair—as it declares itself in this modern loft.

Section Three

The Finishing Touch

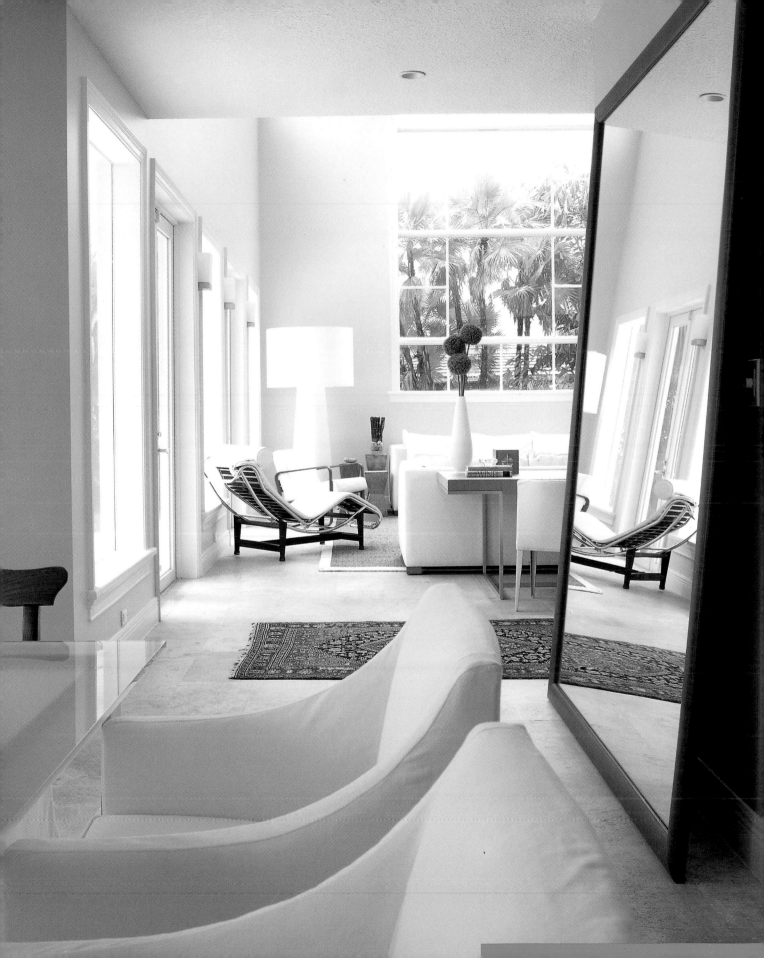

Chapter Eleven: Your Personal Style

Style is the most elusive element of home design. It often seems that choosing the look and feel for your home should be the easy first step. It can be easy to get inspired by the homes you see in magazines, in design books, and on television. To make a style your own, you need to combine various elements that you love and stay far away from those you hate, but it takes a certain amount of courage and confidence to do so. Figuring out your own unique style may, in fact, be the hardest habit to learn.

53. Make your home reflect you and your own personal style.

Tanya Hudson: Yes! Your home is you! One of the great pleasures in designing people's homes is getting into their heads and their lifestyles and then responding to that by creating a home that suits their needs and style.

Celia Domenech: Your house should be you—it's a reflection of your taste and style. It's your home, so it should reflect your personality. That is what makes the space special and different from any other.

Heather Faulding: Even if a home is used mainly for entertaining, it should be a space that echoes the personality of the homeowners. Choosing a less personalized and more neutral scheme may make for easier and quicker shifts of mood and season, but the point of entertaining is to invite people into your own personalized space.

CLS Architetti Studio: Home is the place where people want to live happily and exist comfortably. Going home has to offer joy and positive energy. Designing interiors means understanding the requests and the wishes of people.

Charles Spada: People tend to dress their home the way they dress themselves. If someone is a flashy dresser, then the odds are that his or her home will be flashy, too. I think it's a natural reaction. Otherwise, we would not be very comfortable in our surroundings.

Laurence Llewelyn-Bowen: The best homes are homes that 100 percent reflect the character of the inhabitants (for better or for worse). The issue of good and bad in design has been replaced by a new way of thinking that supports relativity. Your taste might be bad for me, but it's good for you. Be yourself.

This vignette in the living area has Thomas Jayne written all over it. It combines fresh, contemporary color combinations with fine antiques and an incongruous mix of accessories—all against a modern loft backdrop.

"Good design is always on a tightrope of bad taste."
—Elsa Schiaparelli, fashion designer

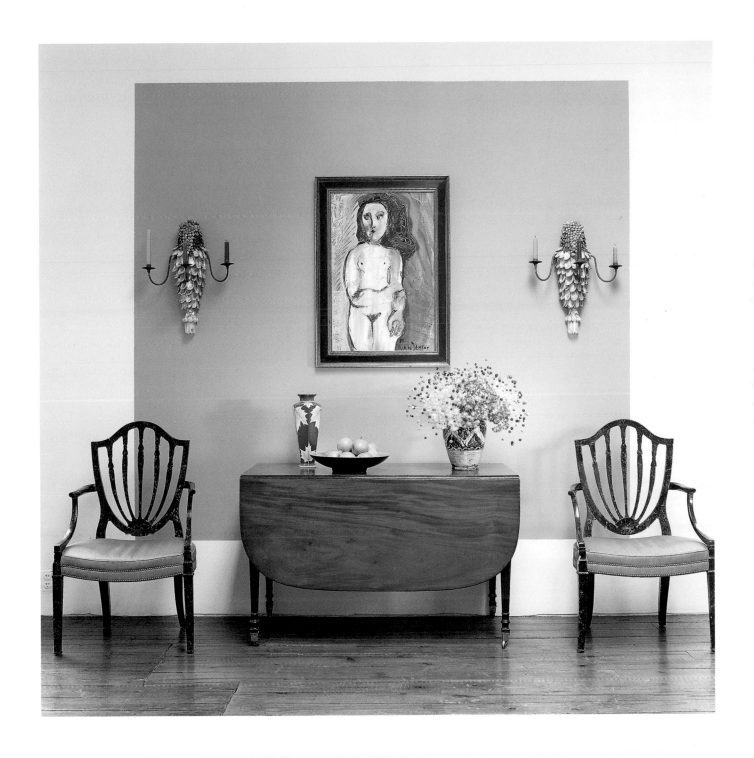

54.

In order to find your personal style, look inside yourself, observe your surroundings, and be brave.

Charles Spada: Style is both an innate and developed expression of one's personal aesthetic. Style is not a quick learn because it is intangible. To reinforce or fine-tune your sense of style, have an open mind—observe and absorb, but know when and how to edit.

CLS Architetti Studio: Style comprises two concepts: One is objective, meaning that some interiors have a natural style, like ancient interiors—a combination of elements that communicates to you an equilibrium and a feeling of harmony; the other is very personal, meaning that everyone understands what he or she likes and which type of atmosphere is best for him or her. It's a sort of travel inside ourselves.

Laurence Llewelyn-Bowen: In the 18th century, it was believed that style was personal but taste was universal. The former, I believe, still holds true and has superseded the Rule of Taste with a new era, the Supremacy of Taste. Style is you; it is what you want it to be. If I had one immutable piece of advice to impart, it is that the more personal the stylistic expression, the closer to success you'll come.

Axel Verhoustraeten: The only piece of advice you can give is to study or travel and to show an interest in culture rather than in fashion or one's look.

Kelly Wearstler: Be aware of what is around you. Pay attention to fashion and interior store fronts. Style is individual and cannot be learned in magazines, but everything around you can be inspirational in helping to determine your own style.

John Chrestia: If you trust your judgment and are confident about your taste in design, then it will be easy to find a personal style—one that is eclectic, unique, and originally yours. Of course, this does require a bit of confidence.

Tanya Hudson: The best thing to do is to get together loads of samples of materials and colors you like before getting any fixed ideas, and hopefully, in time, your style will emerge and develop.

Heather Faulding: Try to understand and clarify for yourself who you are, how you would like to feel when eating, sleeping, and relaxing. Stay curious, look at environments, and picture yourself in them. Collect images that you like, and you will begin to see your trend. Think out the concept and master plan before making any decisions.

David Ling: I think style is really an outward manifestation of one's inner being. The more in touch and honest you are with yourself, the more natural and authentic the style. Get in touch with yourself, and the rest will follow.

Celia Domenech: Style is your attitude and way of living. It's what feels right, comfortable, and connected to you. Observe your surroundings and see what makes sense to you—there you'll find your own style.

The owners of this southern Florida home are energetic and vibrant. They wanted a soothing interior where they could relax, but one that also felt fresh and energizing. The result is Celia Domenech's blend of modern and casual, a space that feels relaxing yet stylish.

55. Beware of decorating with too many trends.

Robert Cole/Sophie Prévost: There are trends, and there is trendy. Trendy changes quickly, too quickly to be of real value, unless, of course, you are ready to change your decor every six months or so. If that is you, dear reader, please give us a call.

Thomas Jayne: Don't go full tilt on trends unless you are truly, madly, deeply impassioned by any in particular. Being an eclectic collector allows you to play with different, interesting objects, to expand and delete where necessary. Sometimes it is a matter of the colors being out of sync, but if you have good bones—good furniture, antiques, and art—you can always refocus a room with new curtains, new upholstery, new carpet, or new accessories. The pitfall is ending up with nothing that would work in the next generation of your home. How do you know if something will only be a fleeting part of your life and will not end up at Goodwill in a year or two? Maybe your heart was not fully committed to it in the first place.

David Ling: Find your true self, and you won't need to follow the trends. Sometimes it takes a great deal of searching to find what your true style is. Sometimes it's fun just to splash around in fads, but in the end, you are what you eat, what you drive, what you wear, and what you surround yourself with at home.

Tanya Hudson: Good quality furniture and fittings date slower. It's just like buying clothes—you can go mad with a silly, cheap T-shirt and throw it away in six months. You can also buy an ultra-kitsch lampshade or paint the walls an ultra-cool color and change it in six months, but keep the high-fashion statements to easily changeable objects and surfaces.

Kelly Wearstler: Make sure a color or pattern is one that you like. Everything is cyclical. Do not purchase too much of one trend. Always mix colors and periods to avoid a dated look.

Celia Domenech: Don't overdo it. Whatever is trendy should be used on accents and details, but it should not be the base of your design elements. That way, when the season is over, you'll be able to change without too much expense and heartbreak.

CLS Architetti Studio: Keep in mind that a home should be everlasting. Fashion, if you follow it, will always influence interior design, but our approach puts more emphasis on functionality than on fashion.

Charles Spada: Style incorporates color, balance, and proportion and how to take the best of past and current trends to simplify and apply them today. Slaves to fashion should realize how much money is wasted in pursuit of trends. Not only are they costly, they are boring and do not say much for one's individuality.

Laurence Llewelyn-Bowen: Fashion trends yield useful inspiration when you're accessorizing. If you had all the money in the world, you could wear this season's couture then throw it away when the hemlines fall again. By the same token, an entire house swathed in this season's hot pink suede would be a wonderful thing but unlikely to survive the onslaught of next season's patent leather. But a pink suede cushion or two for slight cost can legitimately come into the house and leave again a year later.

Choosing to combine trends based in rococo and chinoiserie is a wise choice made by Charles Spada. Two styles that have been around for centuries are sure to come into fashion every few decades. These classic looks are combined here with contemporary elements, and the result is a timeless and elegant style.

56.

If you are unsure of your style, keep things neutral or go all the way—commit to a single look. If still unsure, hire a pro.

Heather Faulding: When in doubt, remember that less is more—the less color, less pattern, less texture you try to incorporate, the less you can go wrong. Also, stick to one concept—it's either Caribbean or it's Japanese. Fusion style works, but it sometimes take some experience to get it right.

David Ling: There are different types of homeowners: Some want to let it all hang out, and others want to play it safe so the neighbors approve. I've found that many of my clients have a fairly specific personal style but want to commission me as a type of artist, to paint a portrait using their home as canvas.

Thomas Jayne: Good style is good editing. It's about removing possibilities as much as using them. It is almost always better to err toward simplicity. Commit to one mood, essence, or greater purpose. Of course, the dilemma is that great style depends on risks, but if you are unsure, simplicity will usually get you through with aplomb.

Laurence Llewelyn-Bowen: Neutrality is death to design. Realistically speaking, the framework of a room and its more expensive components should create a classic backdrop to more personal statements achieved through more inexpensive accessories. But wall-to-wall neutrality sucks.

Charles Spada: Neutral spaces are often uninteresting, and, in the end, no one is satisfied. The trick is to develop a cohesive plan designed to satisfy everyone who lives there.

John Chrestia: Restraint and respect are a good theme for all of decorating. You must edit your collections and furnishings and always maintain respect for the architecture.

Robert Cole/Sophie Prévost: Do what you feel comfortable with. Trust your instincts. Be brave. And remember: If you don't like it, you can change it. However, the best advice is to hire a professional.

The perfect placement of furniture and arrangement of objects show off the clean lines of the architechture. In fact, David Ling created both the bones and style for this home and was carefully reverent of his well-honed architecture when decorating the strip of mantelpiece.

Chapter Twelve: Accessorize, Accessorize, Accessorize

Face it, some people have a way with accessories and others do not. I, for one, can barely match my earrings to my outfit and usually just go without. Sadly, the same is true for home accessories—I detest tchotchkes but am hardly a minimalist, and combined this somehow adds up to a whole lot of useful and lovely clutter. The designers recommend rotating accessories and, as always, carefully editing. This may not always come so easily, particularly if you don't have an extra "accessories closet," but the lessons remain and each can be customized to your level of accessory expertise.

57. Accessories can make or even remake a room.

Thomas Jayne: Ideally, a room should be great without any objects—the objects are just an added bonus. Pillows can easily tie a room together and change its whole look. Pillows made of old textiles can tone down a newly decorated room. New, modern pillows can give a face-lift to a room with worn decoration. Changing the rugs can shift things in a remarkable fashion, too, or even having no rug. We still dress some of our clients' rooms for summer. In the spring, the carpets are stored and the full curtains are taken down. The furniture is slip-covered and a grass mat installed.

Kelly Wearstler: The larger and more expensive accessories—rugs, furniture, and art—should have the most longevity, whereas pillows, accessories, window treatments, and lighting are easy to change and not as expensive.

David Ling: Accessorizing should work with the environment so that the final selection should bring out the most in the space and the space should bring out the most in the accessory. Accessories are great because they are so easily changeable, in contrast to walls, ceilings, and floors. Accessories can be whimsical and transient, from throws, vases, and rugs to those with meaning, such as heirlooms, family photos, and furniture from your past.

Laurence Llewelyn-Bowen: Nothing lasts forever, and I find nothing stays forever in one place in a room. As the seasons change and the light changes—and even you change—there are new slants and opportunities opening up all the time. Be flexible, and tell each object in your room that it better be prepared to travel.

Heather Faulding: Accessories can be seasonal. They should be rotated so that you can appreciate them afresh. That way, they become more visible and are not cluttered. There are always some that are too precious to put away, though.

Tanya Hudson: Updating accessories can invigorate a space; bedspreads and flowers are good seasonal elements. Accessories are an easy way to follow your changing tastes. We all get fed up with a look after a while.

Celia Domenech: The whole atmosphere can be changed just by rearranging existing accessories, adding some fresh flowers, changing some pillows and throws, and bringing some new pieces here and there.

"Nothing at all is better than second-best. Never fill an empty space just to fill it. Second-best is expensive, while nothing costs nothing." —Billy Baldwin, interior designer

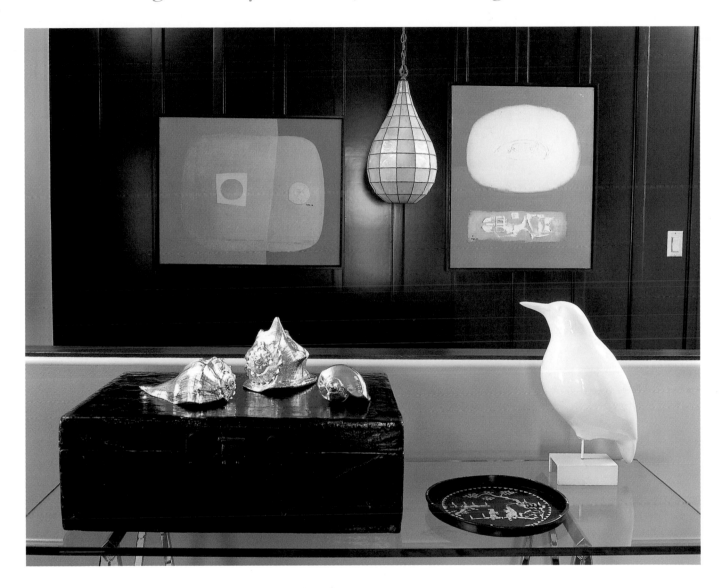

The accessories you choose to display go a long way in telling the story of your style and even hinting at your personality. Here a mixture of brightly colored artwork and shapely shells and sculptures reveal either Kelly Wearstler's or the home-owner's love of smooth designs and intricate shapes.

58. Artfully arrange objects, and choose select groupings.

Laurence Llewelyn-Bowen: Accessories should be sprinkled blindly in a room, without thought or contrivance. Literally just pile all you've got into an area and then begin editing. Take time. Don't rush. Evaluate every object, gauge its visual weight, and decide whether it does the job you had hoped it would. For me, arranging objects successfully is an unending task—no room is ever finished.

Celia Domenech: Accessories bring life to any room. Analyze what the space is asking for after you finish furnishing it: color? shape? whimsy? contrasting textures?

Thomas Jayne: The beautiful arrangement of objects is a talent that is hard to teach. It is an innate skill, though there are some helpful suggestions: Group objects in threes, or balance things in terms of their weight and size in a room—they don't necessarily have to be identical twins. Contrasting textures can work well, such as brass candlesticks on a wooden table, or the texture of a basket on a granite kitchen counter. In modern rooms, accessories often provide the sculpture, so exaggeration of form is a worthy trait.

Charles Spada: The best way to develop a grasp of accessorizing is to study interior design books and magazines. Oftentimes, store and museum displays can be inspirational. A hit of color in a neutral environment becomes the focal point. The eye immediately gravitates to the color. Incongruous pieces work well together if kept at a minimum—for example, a crystal chandelier hung from rough wood or heavy steel beams works together in an unexpected and beautiful way.

Kelly Wearstler: Accessorize with objects that you like. Buy a group of one item in different sizes and colors in order to create depth on a tabletop.

Heather Faulding: Collect things and group them together, but keep a thread running of either the same color, style, or texture with a few sizzlers in the mix.

CLS Architetti Studio: There are no real rules to accessorizing, but the secret is harmony and equilibrium.

A collection of textured aluminum bowls in various sizes is set off by a single, green glass vase standing above the others in the arrangement. In a neutral room, a set of interesting objects or a single brightly colored item may be all that is needed to add a dash of style, as Axel Verhoustraeten has done here.

59. Either carefully edit or relentlessly layer.

Charles Spada: Accessorizing can be a bottomless pit. The trick to accessorizing is knowing when to stop and how and what to edit what you have. A good rule of thumb: For every five items, take out two.

Thomas Jayne: There are too many accessories when you can no longer see the logic of the room or, more important, the people in the room. Think of a crowded room full of, say, Arts and Crafts–style vases—the room becomes only a place to see the things, not to enjoy conversations with friends and family.

Celia Domenech: Accessorizing is totally personal and has to do with the style of the house. For some people, the number of accessories are never enough; for others, one unique piece is more than enough.

Laurence Llewelyn-Bowen: There's a school of thought that says, like jewelry, remove 25 percent before saying you're ready. For me, interiors are so *crashingly* personal that it's impossible to give a rule of thumb.

John Chrestia: Accessorizing is such a personal thing—it depends on each person's style. If you want minimal, then you should only consider few accessories. If you want an opulent look, you'll want a layering of more accessories. I believe it was Coco Chanel who said, "Before you leave the house, take three things off." I agree when it comes to decorating, but I think you should take it even further—before you are done decorating a room, take three, four, or even five accessories out. Editing always helps a room feel more spacious, and it places more significance on the items that remain.

Robert Cole/Sophie Prévost: We often take things away to the point that taking the last thing away makes the room seem too empty. At that juncture, we return the last item removed and call it done. Done is wonderful.

Tanya Hudson: It's totally dependent on the desired end result. If you're after cool minimalism, then you should hold back a bit, but if you're after the harem look, then there's no such thing as too much.

This highly decorated fireplace and fireside table didn't necessarily need a dash of interest, but that didn't stop Laurence Llewelyn-Bowen. Sometimes too much is not even enough when what you are going for is "wild, graphic, and groovy." With its low table and layers of decoration, this bohemian pad makes its statement instantly.

60. Accessories needn't be expensive, but should not be faux precious.

Celia Domenech: For a strict budget or for a casual look, Pottery Barn and other lifestyle chains offer a variety of options that work at an affordable price, especially if you constantly change your accessories.

CLS Architetti Studio: It's a personal choice, but I suggest collecting accessories during your lifetime and when traveling around the world, according to the mood and the taste at the time.

Tanya Hudson: Accessories should have a use; otherwise, they become ornaments (my pet hate!). They are objects that you pick up over time, that grow with the home. Carefully selected knickknacks can look very contrived.

John Chrestia: The accessories in a room should only make up about 10 to 20 percent of the budget. Don't go overboard with lots of expensive items until you have the bones and background of a space completed.

Heather Faulding: If they aren't pretending to be precious, ready-made accessories can be fun—baskets, linens, frames, and so on. The fake precious can be used as party props but are not my thing.

Charles Spada: Accessorizing is usually the last step. Great care should be taken to select only the right items. Quality, not quantity or trends, should be the rule. Collectibles and accessories should have personal meaning, should be lasting, and should reflect a sense of the homeowner, not something one sees in every mail-order catalog. Finally, as in all aspects of interior design, good editing is paramount.

Thomas Jayne: Honesty is always the best policy, even in decoration. Do not try to fake people with an abundance of cheap things that give the false air of being expensive.

Laurence Llewelyn-Bowen: Value should always be irrelevant to the designer. If an object gives pleasure, it gives pleasure. If it only gives pleasure because of its price, there is something wrong with it, and, I'm afraid, something wrong with you! I've never been frightened of reproduction as long as the quality of design and emotional attachment are strong.

Axel Verhoustraeten: Collect on the basis of passion and interest rather than give into the temptation of making stupid but reassuring purchases.

An arrangement of fine accessories that mixes functional with decorative is the ideal setup for this lovely antique table, designed by Charles Spada. Nothing stands out as highly precious, but each item seems equally beautiful. The integration of the whole makes it an effective accessory.

Chapter Thirteen: Artful Displays & Collections

Artwork is like an accessory with a pedigree. It is either a precious purchase or part of a prized collection, and it requires more attention than simple, edited arrangements. Art must be framed, either literally or figuratively, so that it can be properly revered. Of course, no work of art is more important than the function of your home. Your living room should not feel like a museum, and no display of art should interfere with your comfort. Instead, artwork should enhance your decor and add to your enjoyment of home.

61. Art should enhance your decor, not cater to it.

Thomas Jayne: The relationship between art and decoration should be mutual admiration. Great art looks best with good decoration. It is hard to have great decoration without art. So if a client has two Picasso sculptures or a collection of French pictures, I take them into account. However, I do not match the sofa to a lady's dress in a painting.

Tanya Hudson: Art is personal and should be collected over time as a record of your experiences.

John Chrestia: Remember that the main focus of a home is living. This isn't a museum where people are coming to see your artwork displayed. It should feel warm and welcoming, no matter what.

Laurence Llewelyn-Bowen: Inevitably art becomes sucked into design, which as a fine artist I have no problem with. Art should be as sympathetic to the room as the room should be to the art.

Axel Verhoustraeten: Art is never too much! A collection is not a question of value but a question of passion. Decoration is nothing; art is everything!

CLS Architetti Studio: In 1950s Italy, many artists worked in cooperation with architects to paint directly on the walls or ceiling. These interiors were done by hand, and the work was high quality. Unfortunately, this method is now lost, and today artwork is simply bought. Art should be part of life, but buying art shouldn't be like buying a rug. Art is a passion—pieces should be sought out or discovered.

Robert Cole/Sophie Prévost: Whenever possible, we encourage our clients to purchase artwork, not to enhance the decoration, but rather to enhance their lives. Most people have stereos that cost as much or more than a good print, but they balk at the suggestion of buying "art."

David Ling: I think that art and interior design should enhance one another. All interior work is a dialogue between the space, light, objects, furniture, and definitely the art. In the past I have designed walls, niches, and pedestals to fit the art like a glove. I prefer this to the warehouse approach where everything is lined up like ducks in a row. I love idiosyncratic settings for idiosyncratic pieces.

Heather Faulding: Art is the signature of a space, and it should be part of the design plan from the beginning.

"Beautiful things are faithful friends, and they stay beautiful as they get older." —Elsie de Wolfe, decorator

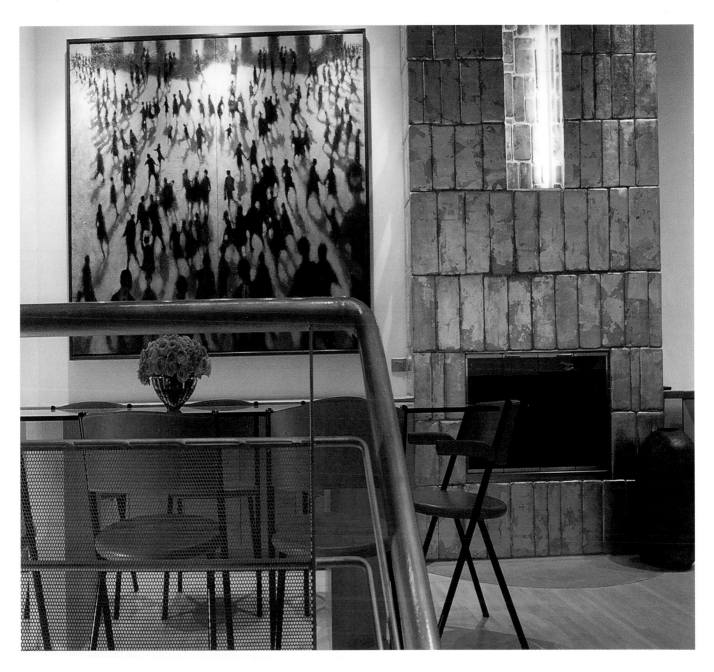

This dining nook was designed with this particular piece of art in mind. But the designer, Heather Faulding, did not point to the painting—she simply referred to it with the color and textures in the fireplace. Artwork is always a useful addition to any dining space because it adds a note of drama and importance to the room.

62. Display your collections proudly—perhaps in rotation—but don't go overboard.

John Chrestia: Art has to look natural and relaxed in a room. The tendency to create a kind of altar to a collection or the idea of showcasing an important painting over the mantel is uninteresting and too straightforward. A collection that takes over an entire cabinet or shelves should not be the focus of the room.

Heather Faulding: Consider unexpected places to put things that are unusual: very high or very low, in hallways, above picture rails, up the side of stairs, across a window ledge. You can also rotate a collection from storage to shelves to maximize the enjoyment of each piece.

Celia Domenech: Analyze the collection, find the most attractive qualities—shape, color, and texture—and then figure out the best way to expose them using background, light, angles, and storage technique.

Thomas Jayne: Display collections on special bases or mounts so that there is a regular element to contrast with the irregular shapes of the collection. This could mean special boxes or panels, in clear-finished wood, paint, or fabric. It gives cohesion to the collection. I try to keep collections of a single type of item—say, art glass vases—from being displayed in every room of a house. It tends to cheapen their value and make the collector seem particularly obsessed.

Laurence Llewelyn-Bowen: Disparate objects should be set against a strong—either in texture or color—coordinating background to create a frame. It's a truism that higgledy-piggledy collections of multicolored book spines always look better on dark or rich-colored shelves, so use this as inspiration for displaying collections.

David Ling: The more diverse the collection, the more complex the problem. A variety of display niches, shelves, walls, and pedestals help to accommodate varying scales, materials, and colors. Sometimes I also create deep niches to contain and isolate a really wild piece.

Tanya Hudson: Display collections using repetition and density—in long rows or filling up an entire wall.

Charles Spada: Collections should be kept to a minimum. When there is a collection of more than one type, each should integrate with one another smoothly, not compete for attention. Edit collections by displaying only the best. Don't display a mumble jumble.

Robert Cole/Sophie Prévost: Be selective about the display of collections by rotating items. This allows you to "see" the objects more clearly. Displays that stay the same tend to fade into the background of one's sensibility, becoming more like wallpaper than something special.

Kelly Wearstler: Creating tension with art and decor is interesting and unexpected. A modern abstract setting is fabulous with more traditional frames and artwork.

ColePrévost specially designed these built-in cubbyholes, which are divided with panes of frosted glass to keep this collection of artifacts looking special and organized. The way that each item is in its own space allows the importance of each one to be considered, but on the whole, the collection feels worldly, modern, and colorful.

63. Choose a frame and framing pattern to match the art, not the decor.

Laurence Llewelyn-Bowen: Always hang pictures so that the final row corresponds with your eye level, regardless of the size of the room. I like grouped pictures that unite through similarity of image or that are brought together through the use of corresponding framing techniques.

Thomas Jayne: Art should be framed for the work of art itself. Modern rooms sometimes demand modern frames, even if the work of art is older. If the matting and frame match the wall, then the work of art should be minor, say a botanical print. Imagine a Rembrandt in a frame that matched the wall.

Heather Faulding: Grouping is great for the story of it. Matting should make the art look great and only bear the room in mind.

Charles Spada: Framing and matting artwork should be done with the art in mind, not the decor. Otherwise, the art never works. Only appropriate objects should be framed, such as those objects dear to our hearts—children's art, diplomas, and photographs of family, friends, and pets.

Kelly Wearstler: I love layering an artwork, for example, hanging a frame with incredible matting against a beautifully textured linen or silk wall. Make sure the art is hung at a good height—not too low or too high. Otherwise, it can be an art-buzz kill.

Celia Domenech: I like contrasts between the wall and the framing. Most important is that the frame should bring out the best of the artwork and not the opposite. Sets of black-and-white photographs framed in dark wood with archival mat board bring a clean, simple, and smart look.

Tanya Hudson: I think it's fun if the framing suits the artwork, and you have lots of different frames. On a wall, it creates an interesting texture.

Robert Cole/Sophie Prévost: The choice of matting is often to highlight the work and is rarely chosen to match the walls. If anything, we might alter the background color to complement a specific piece of art. A frame highlights the thing being framed. Accordingly, anything that adds a sense of delight to one's life is game. We have seen several blank frames put on a wall, and tiny photographs framed in large, even huge, frames. It is the juxtaposition that creates a sense of interest because it creates the unexpected.

David Ling: There are so many ways of arranging photos. The more regular the frame sizes, the more evenly they can be spaced. The more irregular the frame sizes, the more randomly they can be placed.

Devoting an entire wall to several framed pieces ensures that the pattern of the art, rather than the framed items themselves, becomes the focus. In this case, Charles Spada makes a collection of landscapes along with artist sketches take a backseat to the reflected bust and the gilded mirror. As a whole, however, the wall of art feels creative and interesting.

64. Everyday objects, when purposefully displayed, also count as art.

Laurence Llewelyn-Bowen: I love to see framed maps in a room, but even sumptuous fabric swatches, wonderful wallpapers, or architectural plans, when lovingly framed, can bring a room alive.

Celia Domenech: Rustic wood or woven wicker objects, linen and cotton cloths framed in acrylic, shells and starfish displayed on top of ledges can act as art. In my house, we have a thick, twisted vine trunk, which we cut from our garden, illuminated with a spotlight, and it looks beautiful.

David Ling: I think the first place to start is everyday objects that you use constantly. In the kitchen, it could be a beautiful set of cookware, great-looking appliances, fabulous flatware, or luscious linens. In the bathroom, I like to start with great fixtures or sensuous tilework. In any case, it's not just the objects: Light can make an ordinary object look special; darkness can make the most precious object look dull. Light can be your friend.

Thomas Jayne: Generally, snapshots belong in albums. I have seen them effectively used in collages, say, of family vacations, or arranged with items of historical significance to a family. This, of course, must be done with an artist's eye. It is effective when done right. I like regular grids of snapshots, too. Be careful to update them when they get tired looking. Color photographs tend to discolor and look ugly after a while. There is great value in Japanese wood blocks and contemporary prints. These start as low as $25, so there is really no excuse for not having some original art. I think found objects can be elevated to art, if you develop an eye for it, say, a worn sign or an oxidized piece of metal. Textiles also frame well as art.

Heather Faulding: Almost anything can be special. I love packaging on almost anything.

The illuminated photo sculpture at the rear of this apartment was once a small photograph, but after being enlarged, zoomed in on, and well lit, the close-up of foliage becomes a fascinating piece of art. Milan-based CLS Architects commissions lighting designers to help design and invent new ways to make walls into artwork with lighting and computer technology.

Chapter Fourteen: The Wisest Words

Many people believe that because someone was trained in a specific profession or because they've enlisted them for help with a specific task, the person should have all the answers—that pearls of wisdom should drop from their lips. All of us are desperate to learn the secrets of the successful and the tricks of the trade from professionals. Often we are disappointed by the advice we're given. It's no surprise that "practice makes perfect" and that "rewards require risks."

When it comes to design, it really does feel as though it's all a great big mystery that could never be summed up with three little magic words, although Mies Van der Rohe's "less is more" has certainly served us well. Instead, the secret of design is constantly under debate. Like a town meeting determined to find the right answer, it takes many minds and many sage words. When asked for the ultimate advice, this is what our 12 outspoken designers had to say.

65.

The general rule that holds true is that there are no general rules. I try to take each space, each client, each budget as a unique set of conditions that requires a unique set of selections, editing, and dialog.

David Ling

66.

Less is more. Keep it refined and delicious.

Charles Spada

67. The best decoration is a distillation of the ancient and the modern.

Thomas Jayne

68. We hate things that match perfectly. We love the unexpected element—the clash that breaks the rules and creates the charm.

Robert Cole/Sophie Prévost

69. I love beauty but hate clutter. Beautiful objects, fine furniture, and special textures against a clean, simple backdrop make for soothed, uncluttered minds.

Heather Faulding

70. Design always reflects the personality of the inhabitants and is never made for the mere purpose of decoration.

Axel Verhoustraeten

71.

Decoration must always take into consideration the spirit of the home and its architecture. You can make a historic home feel sleek and modern but don't deface the pedigree in an effort to make it contemporary.

John Chrestia

72.

People tend to split design into function and aesthetics, but in good design there isn't really a distinction; one reinforces the other. Designs that function well are enjoyable to use, and often their rationality is attractive. Designs that are attractive, we enjoy using and inhabiting. I don't believe homes should be objects to admire; they should be fun places where we simply happen to live.

Tanya Hudson

73.

Flowers are the most luxurious accessory. I like them just after they've bloomed, when they are almost on their way out—I think that is the most beautiful moment for a flower.

CLS Architetti Studio

74. Design is translating the soul, the mood, and the spirit into three dimensions.

Heather Faulding

75. Dress your home as you dress yourself. Have fun with colors and fabrics. There are no rules.

Kelly Wearstler

76. The best quote on interior design comes from the impressively bearded William Morris: "Have nothing in your home that is neither beautiful nor useful."

Laurence Llewelyn-Bowen

77. You always have to be able to justify your choices. Casual good taste betrays a lack of culture.

Axel Verhoustraeten

Designer Directory

John Chrestia
Chrestia Staub Pierce
7219 Perrier St.
New Orleans, LA 70118
(504) 866-6677
jchrestia@cspdesign.com
www.chrestiastaubpierce.com

Robert Cole/Sophie Prévost
ColePrévost, Inc.
1635 Connecticut Ave., NW
Washington, DC 20009
(202) 234-1090
cp@coleprevost.net
www.coleprevost.net

CLS Architetti Studio
Massimiliano Locatelli, Giovanna Cornelio &
 Annamaria Scevola
Via San Maurilio 24
20123 Milano
Italy
+39.02.866247

24 54th St.
New York, NY 10022
(212) 750-0151
www.clsarchitetti.com

Celia Domenech
LID—Living Interior Design, Inc.
337 Palermo Ave.
Coral Gables, FL 33134
(305) 447-3005
livingdgn@aol.com

Heather Faulding
F2, Inc./Faulding Architecture
11 E. 22nd St.
New York, NY 10010
(212) 253-1513
info@f2inc.com
www.f2inc.com

Tanya Hudson
Amok Ltd.
Unit 7, Town Mead Business Centre
William Morris Way
London SW6 2SZ
44(0) 020 7731 6104
tanya@amokltd.com
www.amokltd.com

Thomas Jayne
Thomas Jayne Studio
136 E. 57th St., #1704
New York, NY 10022
(212) 838-9080
www.thomasjaynestudio.com

David Ling
David Ling Architect
225 E. 21st St.
New York, NY 10010
(212) 982-7089
lingarch@inch.com
www.davidlingarchitect.com

Laurence Llewelyn-Bowen
Llewelyn-Bowen Ltd
40 Stockwell St., Greenwich
London SE10 8EY
44 (0) 208 269 2521
www.llb.co.uk

Charles Spada
Charles Spada Interiors/Antiques on 5
One Design Center Pl., Suite 547
Boston, MA 02210
(617) 951-0008
Antiques5@aol.com

Axel Verhoustraeten
AXV Bureau d'Etude
9 Avenue du Vert Chasseur
1180 Bruxelles
02 511 54 43.
info@axv.be
www.axv.be

Kelly Wearstler
KWID
317 N. Kings Rd.
Los Angeles, CA 90048
(323) 951-7454
www.kwid.com

Photographer Credits

©BBC Photo Library, 10 (bottom); 29; 37; 49; 95; 135

Gordon Beall, 58; 89

Timothy Bell, 17; 93; 141

Antoine Bootz, 59

Arthur Cohen, 10 (top)

Grey Crawford, 7; 25; 57; 61; 131

Guillaume De Laubier, 11 (middle); 21; 39; 69; 87; 99; 101; 105; 107; 113; 133

Guillaume De Laubier/Axel Verhoustraeten, 4; 65

Carlos Domenech, 9 (top); 43; 51; 73; 91; 103; 115; 125

Carlos Domenech/Celia Domenech, 121

Lee Foster, 9 (bottom)

Scott Frances, 45; 77; 79

Violet Frasier, 10 (middle)

Giovanni Gastel, 8 (bottom)

Mark Edward Harris, 10 (bottom)

Andrea Martiradonna, 27; 145

Cristian Molina/Cole/Prévost, Inc., 153; 159

Photo by Celia Pearson, as seen in Metropolitan Home May/June 2002, 8 (middle)

Eric Roth, 6; 11 (top); 55; 67; 83; 119; 127; 137; 143

Michael Scates, 23; 31; 63; 84; 85; 97

Michael Scates/Amok Ltd., 155

Angela Seckinger, 71; 117

Richard Sexton, 8 (top); 33; 47; 109

Stuart O'Sullivan, 9 (middle); 40; 41; 139

Stuart O'Sullivan/F2, Inc., 13, 157

William Waldron, 19; 35; 75; 81; 111; 123

Kevin Wilson, 53

Gabi Zimmerman, 15; 129

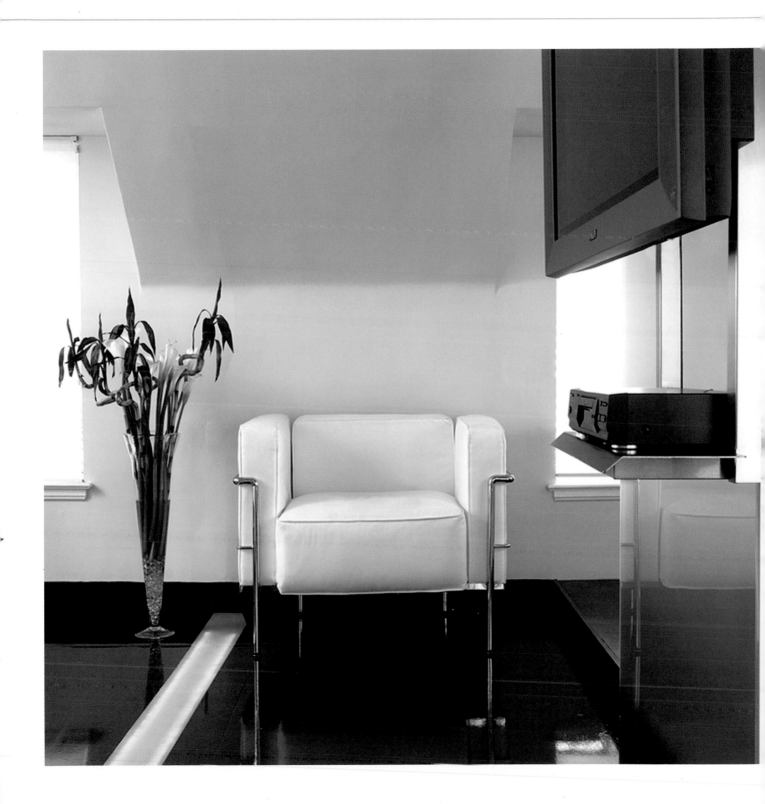

Acknowledgments

This project has materialized thanks to the effort of many different people and would not have come together were it not for this successful collaboration. Each designer who participated worked exceptionally hard to answer my never-ending interview questions with replies that were thoughtful, well spoken, and usually on deadline.

The book would not have gotten off the ground were it not for Rockport's Betsy Gammons and her constant brainstorming, organized advice, and tireless photo research. Lastly, the job of unifying 12 disparate voices and grammatical styles was not easy, but project manager and copyeditor Pamela Hunt has done a wonderful job of injecting accuracy and consistency into the mix.

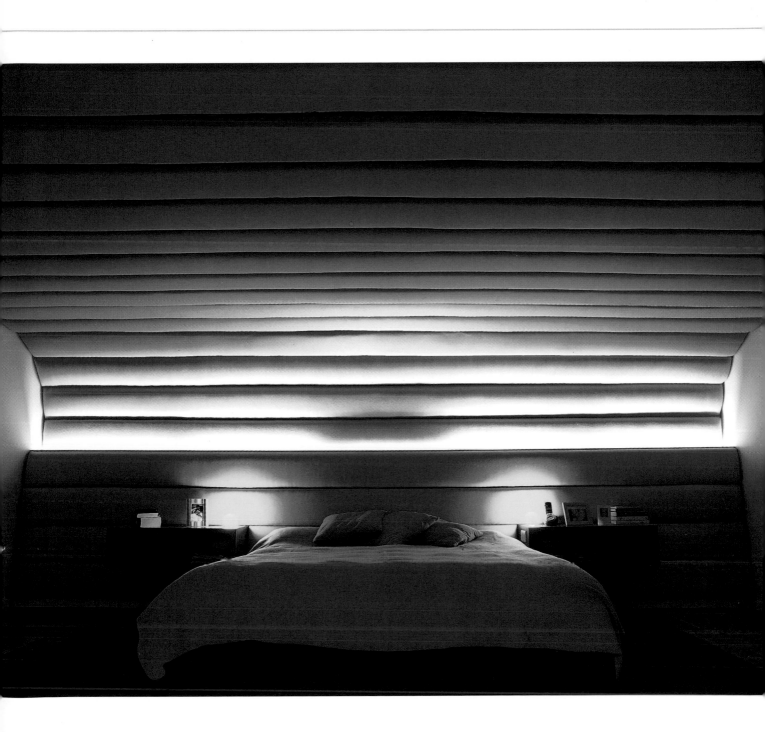

Dedication

This book is dedicated to the 12 talented and extremely busy design teams who wrote it, as well as to any of their assistants who may have helped me pin them down and assault them with question after question. Thank you.

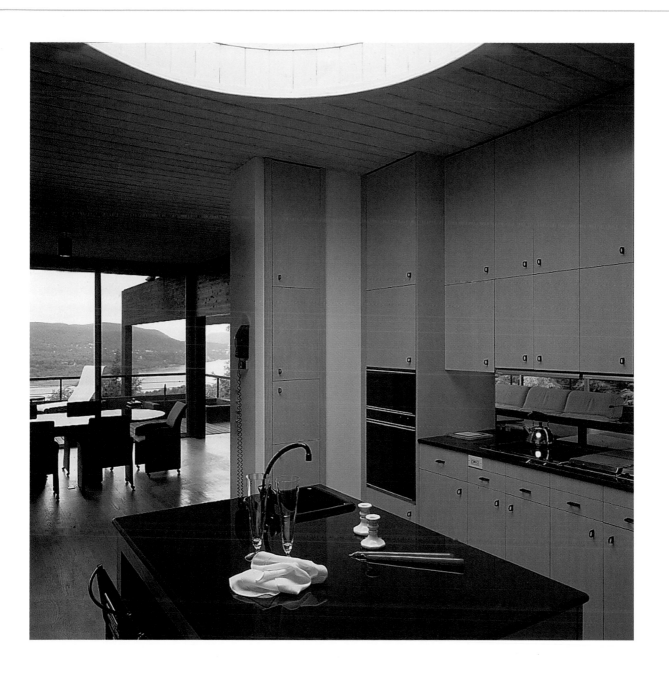

About the Author

Interior design writer and editor Sarah Lynch writes the monthly "Colorways" column for *Metropolitan Home* magazine. She is the author of *The Perfect Room* and *Bold Colors for Modern Rooms* (both from Rockport Publishers). She lives in New York City.

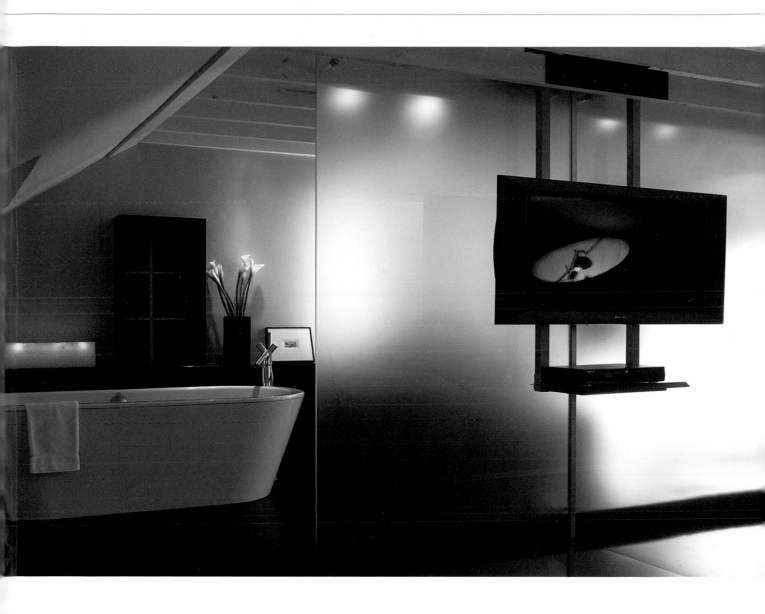